A String of Pearls

Landscape and literature of the Lake District

"On a sunny day, with the tarns sparkling like jewels
and the larks singing, the top of Haystacks becomes
a fairyland, and the line of lakes, far below,
a string of pearls."

– from *A Year in the Fells* by A. H. Griffin

A String of Pearls

Landscape and literature of the Lake District

COMPILED BY MARGARET WILSON
PHOTOGRAPHS BY HELEN SHAW

MERLIN UNWIN BOOKS

First published in Great Britain by Merlin Unwin Books Ltd 2021

Merlin Unwin Books Ltd
Palmers House, 7 Corve Street, Ludlow
Shropshire SY8 1DB England

www.merlinunwin.co.uk

ISBN 978-1-913159-24-5
Typeset in 13 point Caslon by Merlin Unwin Books
Printed by 1010 Printing International Ltd

Half-title page: Rannerdale Farm, below Whiteless Pike
Title page: Crummock Water looking towards Buttermere

Acknowledgements

My very grateful thanks to Karen McCall and Merlin Unwin at Merlin Unwin Books for all their work and support on this book, but particularly to Joanne Potter for dealing with the tremendous complexities of permissions for an anthology. I would also like to thank the staff at the Armitt Museum, Ambleside, Jane and Harvey at Hill Top, Sheila Briggs at High Wray Farm, and Dr Will Smith, for their help and suggestions, and the authors and poets whose writing inspired us to create this anthology. Lastly, my very special thanks to Helen Shaw for her unstinting work to obtain such wonderful photographs, and apologies for the 3am starts and the fact that we couldn't use all of those beautiful images!

Margaret Wilson

CONTENTS

EDITOR'S PREFACE

The relatively small area of the Lake District has seen many visitors over the last 6,000 years or so. Neolithic man produced axes from the hard greenstone of the Langdale Pikes. The Romans built forts at Hardknott and near Ambleside, and the road which gives its name to the High Street ridge. Saxons settled and farmed in the lowlands, then Norsemen arrived to farm the higher hills and started building the dry-stone walls. It is these centuries of forest clearing and farming that have shaped the landscape that we know, also leaving linguistic traces in the local words beck, fell, tarn and force.

Early travellers in the Lakes who recorded their experiences include Celia Fiennes in 1698 and in 1724 Daniel Defoe commented that the country was 'the wildest, most barren and frightful of any that I have passed through in England'. Poet Thomas Gray visited in 1769 and wrote of his travels and Thomas West wrote the hugely successful *Guide to the Lakes in Cumberland, Westmoreland and Lancashire* in 1778.

Encouraged by the first proper guidebooks, tourists started to visit the Lakes, but this landscape was initially seen as wild and frightening; visitors were loath to attempt walking in the mountains, that was for sheep farmers and miners. Ann Radcliffe, however, who wrote hugely popular gothic novels, travelled there and climbed the hills then described the experience in extremely flowery language.

William Wordsworth was born in Cockermouth and spent his childhood exploring the hills. He and the other Lakes poets were central to the English Romantic movement and, with Nature as their muse, described the Lakes as wild, but uplifting rather than frightening, which helped alter the way people thought of this dramatic landscape. The Napoleonic wars made the Grand Tour of Europe difficult and increased the appeal of travel through English mountain scenery, helped by a guidebook written by Wordsworth which, to his irritation, was better known then than his poetry. And Alfred Wainwright's beautifully drawn guidebooks have encouraged millions to visit the Lakes but with increased awareness of the toll taken on the landscape leading to greater concern to care for it.

Good writing can always be appreciated, no matter how unfamiliar the setting, but knowing that setting must add to the understanding of it. Wordsworth's words surely resonate a little more with those who have walked in Gobarrow Park where his daffodils grew, or with those who have 'made one long bathing of a summer's day', or with those who, when the tourists have gone, recognise the 'November days, when vapours, rolling down the valleys, made a lonely scene more lonesome.'

People who grow up in the area (Wordsworth, Norman Nicholson, James Rebanks) know how lucky they are to do so but those who choose to move there (Robert Southey, Thomas de Quincey, Beatrix Potter, A. Wainwright) also put down deep roots. The huge variation in geology and therefore landscape produces dramatic peaks, fells and waterfalls, valleys, lakes and gentle pastures which inspire these writers to produce a similarly huge variety of literary works.

I hope that the pieces I selected, this collection of gems made into a string of pearls, matched with Helen's stunning photographs, will delight those who know the area and inspire those who don't to explore our beautiful Lake District, which Wordsworth called 'the loveliest spot that man hath found'.

Margaret Wilson, January 2021

MAP OF LITERARY LAKE DISTRICT

SOLWAY FIRTH

• Maryport

Cockermouth •

• Workington

• Penrith

Bassenthwaite Lake

🌋 Skiddaw

▲ Blencathra

• Keswick

Castlerigg stone circle

Matterdale

Aira Force

Loweswater

Crummock Water

Rannerdale

Derwent Water

St Johns in the Vale

Ennerdale Water

Buttermere

Buttermere church

Borrowdale

Thirlmere

Ullswater

▲ Helvellyn

Haweswater

• Whitehaven

High Street ▲

Innominate Tarn

Pillar ▲

▲ Great Gable

Great Langdale

Wordsworth's cottage

IRISH SEA

Wastwater

▲ Scafell Pike

Grasmere

Rydal Water

Little Langdale

• Ambleside

Eskdale

Ulpha bridge

Old Man of Coniston

Esthwaite Water

• Windermere

• Ravenglass

▲

Duddon Valley

Coniston Water

Grizedale

Windermere

• Kendal

Broughton in Furness

Millom •

Grange over Sands

Barrow in Furness

• Carnforth

MORECAMBE BAY

WILLIAM WORDSWORTH

I Wandered Lonely as a Cloud

I wandered lonely as a cloud
That floats on high o'er vales and hills,
When all at once I saw a crowd,
A host, of golden daffodils;
Beside the lake, beneath the trees,
Fluttering and dancing in the breeze.

Continuous as the stars that shine
And twinkle on the milky way,
They stretched in never-ending line
Along the margin of a bay:
Ten thousand saw I at a glance,
Tossing their heads in sprightly dance.

The waves beside them danced; but they
Out-did the sparkling waves in glee:
A poet could not but be gay,
In such a jocund company:
I gazed—and gazed—but little thought
What wealth the show to me had brought:

For oft, when on my couch I lie
In vacant or in pensive mood,
They flash upon that inward eye
Which is the bliss of solitude;
And then my heart with pleasure fills,
And dances with the daffodils.

*On 15 April 1802, William Wordsworth was walking
with his sister, Dorothy, when they saw a 'long belt' of
tiny wild daffodils, fluttering on the shores of Ullswater.
This inspired his best-known work and one of England's
most famous poems, known by many simply as 'Daffodils'.*

Right: Dora's Field, St Mary's Church, Rydal

JOHN KEATS

Imitation of Spenser

Now Morning from her orient chamber came,
And her first footsteps touch'd a verdant hill;
Crowning its lawny crest with amber flame,
Silv'ring the untainted gushes of its rill;
Which, pure from mossy beds, did down distill,
And after parting beds of simple flowers,
By many streams a little lake did fill,
Which round its marge reflected woven bowers,
And, in its middle space, a sky that never lowers.

Keats was one of the later British Romantic poets; his work still focused on nature and the uplifting power of its beauty. This is from one of his earliest works which was inspired by reading Spenser's Færie Queene. *Keats visited the Lakes in 1818 for a walking tour and was disappointed to find Wordsworth out, canvassing for Lord Lowther, when he called at Wordsworth's home, Rydal Mount.*

Left: Latrigg looking south to King's How and the Borrowdale Fells

11

THOMAS GRAY (1716-1771)
Ullswater in Autumn

Oct. 1 (1769). A grey autumnal day, the air perfectly calm, and mild, went to see Ullswater, five miles distant… Walked over a spongy meadow or two, and began to mount the hill through a broad straight green alley among the trees, and with some toil gained the summit. From hence saw the lake opening directly at my feet, majestic in its calmness, clear and smooth as a blue mirror, with winding shores and low points of land covered with green inclosures, white farm houses looking out among the trees, and cattle feeding. The water is almost every where bordered with cultivated lands, gently sloping upwards from a mile to a quarter of a mile in

breadth, till they reach the feet of the mountains which rise very rude and awful with their broken tops on either hand. Directly in front, at better than three miles distance, Place-fell, one of the bravest among them, pushes its bold broad breast into the midst of the lake, and forces it to alter its course, forming first a large bay to the left, and then bending to the right.

From *Thomas Gray's Journal of his Visit to the Lake District in 1769*

The poet, historian and scholar, Thomas Gray was one of the first major literary figures to visit and write about the Lake District. Gray's account of his 14-day tour was published as an appendix to the second and subsequent editions of Thomas West's Guide to the Lakes.

Below: Place Fell, Ullswater

HARTLEY COLERIDGE

November

The mellow year is hasting to its close;
The little birds have almost sung their last,
Their small notes twitter in the dreary blast –
That shrill-piped harbinger of early snows;
The patient beauty of the scentless rose,
Oft with the Morn's hoar crystal quaintly glass'd,
Hangs, a pale mourner for the summer past,
And makes a little summer where it grows:
In the chill sunbeam of the faint brief day
The dusky waters shudder as they shine,
The russet leaves obstruct the struggling way
Of oozy brooks, which no deep banks define,
And the gaunt woods, in ragged, scant array,
Wrap their old limbs with sombre ivy twine.

Hartley Coleridge (1796–1849), poet and writer, was the eldest son of Samuel Taylor Coleridge.

Right: near Elterwater on a frosty winter morning

MELVYN BRAGG

The Maid of Buttermere

Although Hope saw no sign of his looking back, he waited until Burkett was out of sight, to be quite sure, and then struck up for Sprinkling Tarn.

This was a larger but wilder stretch of water than Styehead. The high-massed and perilous crags of Great End were in prospect; and the name could have stood as the epitaph for the whole place. Hope could not recollect anywhere on earth he had been that was so barren, inhospitable, and full of potential terror. Even the sheep which scaled and gave some life to the most remote districts were absent from this spot, which could truly be thought of, Hope considered, as God-forsaken. Those who found a paradise in the Lakes should come here now and see what lay at the true heart of it.

But then, as if directly sent to contradict and vanquish such thoughts, a rainbow grew into the sky coming up from where they had begun their upward climb and arcing perfectly across the front of the Gables to fall away towards Wast Water. Hope was entranced.

The Maid of Buttermere, Melvyn Bragg © 1987 Melvyn Bragg reproduced by permission of Hodder and Stoughton

In the early 19th century, Mary Robinson, daughter of the landlord of the Fish Inn, was a renowned beauty, known as the Maid of Buttermere and her marriage to the brother of an earl sparked the interest of the country. Unfortunately, this included the earl in question whose brother was actually in Vienna at the time so who had Mary married?

Left: Great Gable from Wasdale Head

WILLIAM WORDSWORTH

Lines Written in Early Spring

I heard a thousand blended notes,
While in a grove I sate reclined,
In that sweet mood when pleasant thoughts
Bring sad thoughts to the mind.

To her fair works did Nature link
The human soul that through me ran;
And much it grieved my heart to think
What man has made of man.

Through primrose tufts, in that green bower,
The periwinkle trailed its wreaths;
And 'tis my faith that every flower
Enjoys the air it breathes.

The birds around me hopped and played,
Their thoughts I cannot measure:—
But the least motion which they made
It seemed a thrill of pleasure.

The budding twigs spread out their fan,
To catch the breezy air;
And I must think, do all I can,
That there was pleasure there.

If this belief from heaven be sent,
If such be Nature's holy plan,
Have I not reason to lament
What man has made of man?

Written at the time of the French Revolution, some of which he had witnessed, Wordsworth is initially musing on the beauty of the natural world before his thoughts turn to the darker aspects of humankind.

Right: near the Bowder Stone, Borrowdale

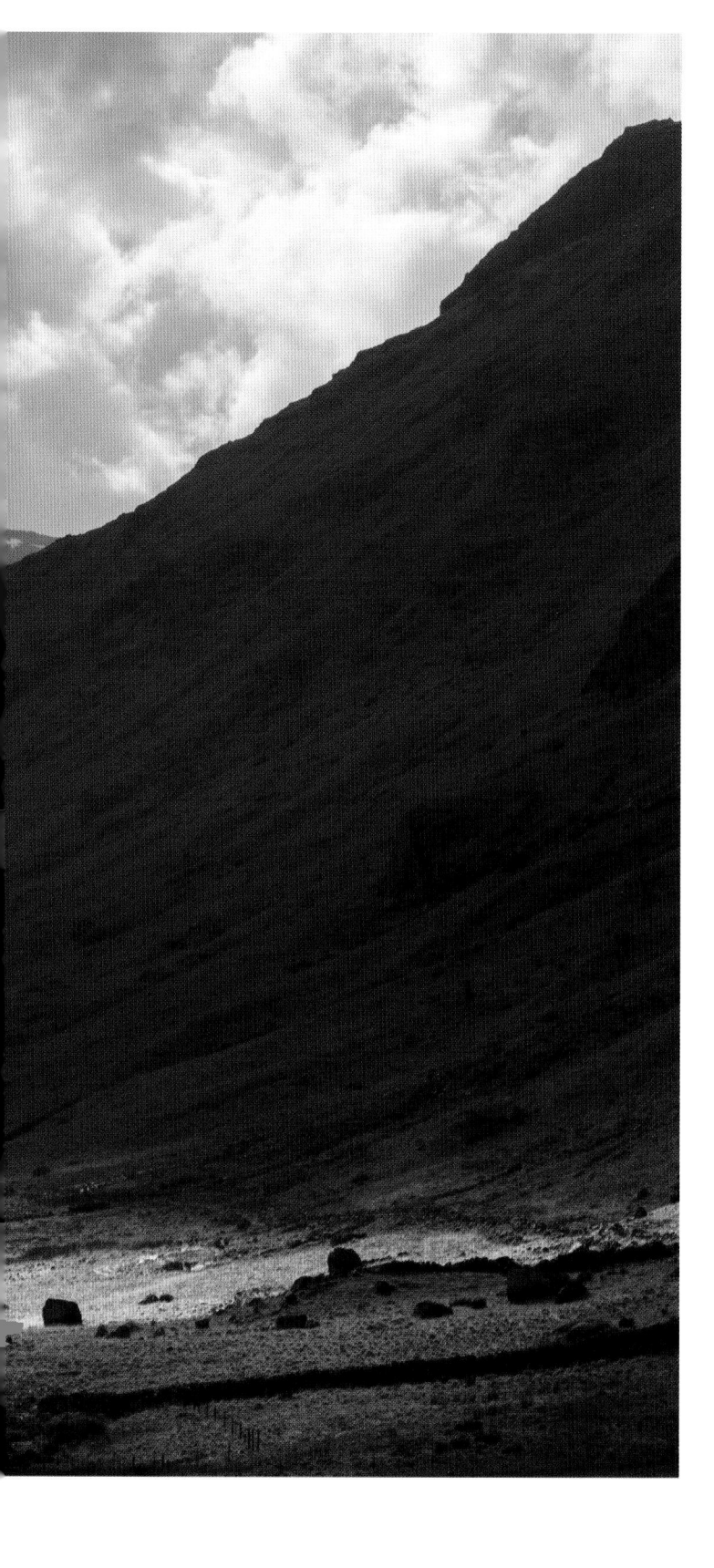

IAN McEWAN
Amsterdam

During the first hour or so, after he had turned south into the Langstrath, he felt, despite his optimism, the unease of outdoor solitude wrap itself around him. He drifted helplessly into a daydream, an elaborate story about someone hiding behind a rock, waiting to kill him. Now and then he glanced over his shoulder. He knew this feeling well because he often hiked alone. There was always a reluctance to be overcome. It was an act of will, a tussle with instinct, to keep walking away from the nearest people, from shelter, warmth and help. A sense of scale habituated to the daily perspectives of rooms and streets was suddenly affronted by a colossal emptiness. The mass of rock rising above the valley was one long frown set in stone. The hiss and thunder of the stream was the language of threat. His shrinking spirit and all his basic inclinations told him that it was foolish and unnecessary to keep on, that he was making a mistake.

Clive kept on because the shrinking and apprehension were precisely the conditions – the sickness – from which he sought release, and proof that his daily grind – crouching over that piano for hours every day – had reduced him to a cringing state. He would be large again, and unafraid. There was no threat here, only elemental indifference.

Amsterdam, Ian McEwan
Vintage/Penguin Random House, 1998

This novel won the Booker Prize in 1998 although it seems to be one of Ian McEwan's less popular works. It deals with an unravelling friendship and moral dilemmas, with a wonderful description of a fairly unpleasant character seeking inspiration in the wilderness of the Lakes.

Left: Langstrath looking towards Esk Pike

JOHN WOODCOCK GRAVES

D'ye ken John Peel?

D'ye ken John Peel with his coat so gray,
D'ye ken John Peel at the break of the day,
D'ye ken John Peel when he's far, far away,
With his hounds and his horn in the morning?

Chorus
For the sound of his horn brought me from my bed,
And the cry of his hounds which he oft-times led;
Peel's view halloo would awaken the dead,
Or the fox from his lair in the morning.

Yes, I ken John Peel and Ruby too!
Ranter and Ringwood, Bellman and True,
From a find to a check, from a check to a view,
From a view to a death in the morning.

Then here's to John Peel from my heart and soul,
Let's drink to his health, let's finish the bowl,
We'll follow John Peel thro' fair and thro' foul,
If we want a good hunt in the morning.

John Peel – English farmer and huntsman, born Caldbeck, probably 1776, died November 1854. The words to this well-known hunting song were written (in Cumbrian dialect) by Peel's friend John Woodcock Graves. There are several different versions and they were also rewritten for clarity by George Coward and published in a book of Cumberland songs in 1866.

Below:
Underskiddaw looking up to Skiddaw Little Man

BILL BRYSON

The Road to Little Dribbling

Keswick is the main community on Derwent Water and I think is the most pleasant town in the Lakes. The main street had been pedestrianized since I was last there, and was much improved for it. I was pleased to see that Bryson's Tea Room (est. 1947) is still going strong. I walked down to and then partway around the lake. It really is quite sensationally lovely, with clear, sparkling water spread beneath a backdrop of craggy mountains of stone and sheep-nibbled grass.

A couple of hundred yards offshore is a wooded island, called Derwent Island, with a grand house on it. An information board from the National Trust informed me that an eccentric eighteenth-century owner named Joseph Pocklington held a regatta every year 'where he challenged the people of Keswick to attack the island while he shot at them with his cannons'. They certainly know how to have a good time in the Lake District, it seems. I would love to have seen the island, even without cannon fire, but it is not generally open to the public, so I contented myself with an hour's ramble at the lake's edge.

The Road to Little Dribbling: More Notes from a Small Island, Bill Bryson, Transworld Publishers/Penguin Random House, London, 2015

Bill Bryson travels around Great Britain to see what has changed in the twenty years since publication of Notes from a Small Island.

Left: Keswick and Skiddaw

MAGNUS MILLS

All Quiet on the Orient Express

As I approached the line of moored boats I began to realize that they bore a strong resemblance to the ones in my childhood park. They were all an identical shade of maroon, and even the gold paintwork along the gunwales looked the same. Most striking of all, though, were the ornate prows that rose up at the front of each boat. As a child I'd always been impressed by these because they reminded me of the curved ships from famous legends and fables.

For some reason the raised prows made the boats seem ancient, so that it was impossible to tell whether they were constructed ten, twenty or even fifty years before. It was this sense of agelessness that had always attracted me to them.

Not that I planned to have an 'adventure' in one of these vessels. After all, I was fully aware that they were just simple pleasure craft, built to be hired out by the hour. I was going for nothing more than a simple jaunt on the lake, enjoying the sunshine whilst taking in the scenery, from a new perspective. Nevertheless, by the time I'd chosen a boat and clambered aboard, the thought had been planted in my head that I didn't just want to spend the morning aimlessly rowing about. It would be much better actually to go on a journey somewhere.

Not long after that I hit on the idea of making my way toward the end of the lake, and then having a pint of beer in the Packhorse.

All Quiet on the Orient Express Magnus Mills
Bloomsbury Publishing plc, London, 2011

This is an oddly surreal book about a young man who is camping in the Lakes and ends up staying on to do odd jobs and getting drawn into the remaining local life, after the tourists have gone.

Left: Ambleside, Windermere

ARTHUR RANSOME

Swallowdale

The wind was driving clear down the narrower channel between the islands and the western side of the lake. It was blowing down that narrow passage straight from the Arctic. The channel was rippled with sharp little waves from shore to shore. And already *Amazon* was slipping quietly, slowly, on even keel, into the calms and smooth water of the usual channel under the lee of Long Island.

"We'll beat them yet," said John, and held on his course into the narrow channel along the western shore. "Short tacks it'll be, but a good wind to make them with. We'll beat her yet."

"She's behind the trees now, I can't see her," said Roger.

"You don't need to," said John. "We'll see where she is when we come out the other side of the islands. Ready about!"

Swallow shot up into the wind and a moment later, heeled over on the other tack, was dashing back across the narrow channel. Narrow as it was, every yard of it was good sailing. From shore to island to shore and back again, never for a moment was *Swallow* without a wind to send her singing on her way. "Nancy can't have found anything like this in there behind Long Island," said John, half aloud and half to himself.

They were nearly through the channel, heading for the most northerly of the islands on that side of the lake, when they saw *Amazon's* white sail standing to meet them out from Rio Bay.

"We've beaten her! We've beaten her!" shouted Roger.

Swallowdale Arthur Ransome, Jonathan Cape/Penguin Random House, London, 1931.

Swallowdale is the second book in the Swallows and Amazons series and the Walker children return to the Lakes for another summer of camping, exploring and sailing.

Right: Peel Island on Coniston Water

Above: Pillar Rock, Ennerdale

REGINALD HILL

The Woodcutter

The weather was changing. Clouds were gobbing up the clear blue sky, sinking low enough to obscure the mountain crests and send questing swirls of mist down the rocky slopes. Not normally a fanciful man, Pudovkin was surprised by the thought that it might be Hadda who was summoning these vapours to help conceal him, and when a huge raven swooped out of the crags and croaked mockingly just above his head, it felt like a visitation from an enemy spy.

He waved away these superstitious fancies, but they came flocking back a few minutes later when the track climbed to a prominent shoulder on which stood an imposing cairn.

Straight ahead of him, towering from the mountainside like the ruin of some ancient troll-king's stronghold was a huge jagged rock, dark and menacing, its front plunging precipitously to the valley below.

Here was an explanation of the name Pillar. The fell was named not for its height or bulk but for this single dominant feature. And it was toward this terrifying excrescence that the track was leading.

He could see Hadda clearly, striding onward at the same unrelenting pace. For the first time, doubt seeped into the Russian's mind. This creature he was pursuing was in its own hunting grounds. He was the intruder here.

Then he reminded himself that his quarry was a one-eyed cripple with a maimed hand and no weapon but a long axe. He felt the comforting weight of the Makarov in its shoulder holster and, leaving the cairn behind, he resumed his progress along the path.

Most of the snow had vanished from the track up to Black Sail but here on the north-facing flank of the fell, many of the cracks between the dark crags were still packed white, creating a savage pied beauty that might have appealed to a mind less focused than the Russian's.

Reginald Hill was an English crime writer who was born and bred in Cumbria. He wrote dozens of novels but is best known for those featuring detectives Dalziel and Pascoe. In 1995, he won the Crime Writers' Association Diamond Dagger for Lifetime Achievement.

Above: The lost valley of Mardale now lies submerged beneath the Haweswater reservoir

Haweswater, Sarah Hall, Faber & Faber Ltd, 2003

A novel set in the farming community of the beautiful but remote Mardale valley. With the creation of a reservoir in the 1930s, the valley and its villages of Mardale and Measand were flooded and destroyed.

SARAH HALL

Haweswater

After lunch the men unhooked their horses from the carts and led them to the river to drink, standing in the water up to their knees, their boots skidding on the loose, slippery pebbles, the sucking clay, as the animals shook their noses in the flow. The farmers cupped their hands in the water and poured it over their brown necks. Back in the fields, one man held a bale while another tied it with twine. More men cutting a new section of field. The slow, hand-driven harvester turning. The horses steady, linear in the haze of the valley floor. It was an old dance, the members of the village were used to these movements, though they knew that this would probably be the last haying season in the dale. The last summer.

Later in the day the women joined their husbands, their hair tied back with coloured scarves, bending with forks to lift loose hay up into a cart, the hem of their skirts tucked up into the waistband, ankles scratched by the sharp, cut grass. The drips of blood on their skin firmed into tiny red domes in the heat. Recognizing the potential of the scene, Paul Levell broke with tradition and set his easel up in the field, caught the women and the stacked haycocks with a stroke or two of a brush. He said that posterity favoured life over war, as far as humans were concerned, and so too would he.

They were among the last scenes of Mardale ever to be painted, and in that brilliant season they came away glowing with colour, aesthetic rural compositions. The artist himself wondered at his bucolic creations, mystified by his own visiting serenity.

VAL McDERMID

The Grave Tattoo

As was her habit, Jane walked right up to the edge and carefully sat down with her legs dangling over the lip of the rock shelf, just as she'd done since the first time Matthew had dared her to as a child. The rock formed a shallow U-shape round the waterfall that roared amber and white to her left, and her vantage point provided a breathtaking view of the cascade and the tarn below. Jane couldn't remember a time when Langmere Force hadn't mesmerised her, taking her out of whatever ailed her and making her feel healed. That afternoon was no different. Things slowly slid into perspective and she began to feel the pressure lifting.

The great advantage of an area with few roads was that it made tailing someone very easy. You could hang well back, knowing there were no turn-offs, then narrow the gap when the rare junctions approached. But he hadn't needed to be even that sophisticated as he tailed Jane that afternoon. She'd driven up the hill towards Langmere Stile, an easy follow. And as he'd climbed in her wake, he'd spotted her car in the Langmere Force car park. It would have been hard to miss, really, sitting in splendid isolation near the start of the path.

The Grave Tattoo, Val McDermid. Reprinted by permission of HarperCollins, London © Val McDermid 2006

Award-winning, bestseller writer Val McDermid links a tattooed body in a bog, which could be the corpse of Fletcher Christian, with a missing Wordsworth poem. Christian, mutineer on the Bounty, was a contemporary of Wordsworth's at Cockermouth School.

Right: Kentmere Valley

HUGH WALPOLE

Rogue Herries

Now across the Helvellyn line the scene was black and against the black hung the soft white clouds. Borrowdale glittered in sun like a painted card, flat, emerald and shining.

Above his head all the sky was in motion: beyond him over Honister tenebrous shadows thrust upward to one long line of saffron light that lay like a path between smoking clouds. All the fell smelt of rain and young bracken, and two streams ran in tumult across the grass, finding their way to the beck.

The sunlight was shut off from Borrowdale, which turned instantly dead grey like a mouse's back; then the sun burst out as though with a shout over the low fells that lay before the Gavel. A bird on a rock above the beck began to sing.

Rogue Herries, Hugh Walpole
Macmillan, London, 1930

This is the first novel of four in the Herries Chronicles, a historical family saga set in 18th century Borrowdale and possibly Walpole's best-known work. In 1924 Walpole moved into a house on the slopes of Cat Bells and lived there until his death in 1941.

Left: Borrowdale

PATRICIA NOLAN

Racing the Wind

As summer approached, the nagging time began.

'When can I go into white socks, Mum?'

'When the last snow has gone off Scafell.'

No arguing with that.

'Can I wear summer dresses now? It's *boiling*.'

'*Please* can I go bathing? The others are going.'

There were pools in the river close by, small and rocky, sometimes only waist deep, but any time there was a glimmer of sun we were off across the field with our old faded bathing suits, and would leap into the glassy surface, and plunge to the bottom head-first like squawking ducks, chasing minnows and retrieving stones from the green underworld. We stayed in the water till our teeth chattered and our skin was translucent, and had to play chasing games till we were warm again. Rarely supervised.

I had the good fortune to be born towards the end of July, so my party was often a picnic by the river; the place where we swam is now cordoned off, considered to be too dangerous for access due to a whirlpool further down. It was a perfect site, a good-sized pool and a long stretch of volcanic rock, smoothed away through the ages, where you could tuck in a hollow and chew your sandwich in comfort.

My mother would sit back on a cushion reading *The News Chronicle* while we played.

'Mum, look at me! Look at me!'

'Mrs Nolan! Pat's doing dangerous things!'

'Mmm,' she would say absently, still reading the paper, 'be careful.' Then when she finally looked up, 'Get down off there, now!'

Racing the Wind: a Cumbrian childhood, Patricia Nolan, Merlin Unwin Books, 2019

A beautifully written account of Patricia Nolan's childhood in a tiny, remote community in Eskdale in the 1950s.

Right: A pool in upper Eskdale

Above: Ulpha Bridge in Dunnerdale, a listed structure probably dating from the 17th century

'Gaps in the Duddon Valley', Harriet Fraser, *This Place I Know*, *A New Anthology of Cumbrian Poetry*, Handstand Press, Sedbergh, 2018

HARRIET FRASER

Gaps in the Duddon Valley

On the hill that summer's day, grey cloud hung low like a lid.
Under foot: wet grass, bracken and tormentil standing in for sun.
We passed Low Bridge Beck and Shepherd Gill,
walked beneath broad bog patches and Dawson Pike,
 tracing the wall, the line between intake and fell.

We looked back along Duddon Valley, beyond Turner Hall
over a land of ruffled shadows, woodlands, rock and sky,
onto distant ridges, England's highest crumbs of earth,
across tracks followed by shepherds, for generations,
 while above, two ravens, silhouettes, soared.

Michael's hand raised rocks as big as lambs, and heavier.
As stones were lifted, passed and teased into spaces
and boulders hauled from the chill flow of a beck,
gentle banter and laughter, like moss on rock, formed
 around the edges of this elemental graft.

These walls, land's bones borrowed and stitched by man,
may stand solid for a century. But on a farm this size
there are always gaps, forced by unforgiving rains and snow.
Today two hundred stones are fetched, fitted, back in place.
 Two gaps, three men, one rhythm.

Later, in the kitchen, cups of tea, cake, and Anthony's drawn face
as he tells us that Michael is leaving. All those years
treading this land, learning its ways, kenning the sheep.
His choice forced, no choice, no farm to take on here.
 Now the valley has a gap a man gone, a rare breed.

There's that many, says Anthony,
raising four fingers of a weather-worn hand,
that many young ones in Cumbria who could take over a farm.
 How will you find another like that?

*This Place I Know won first prize for Poetry and Literature at the 2019
Lakeland Book of the Year awards. Harriet Fraser has lived in Cumbria since
1995. She collaborates with her partner, photographer Rob Fraser, through
their practice 'somewhere-nowhere', exploring the nature and culture of place.*

SIMON ARMITAGE

The Candlelighter

From Dove Cottage I sloped out through the side gate
and climbed the corpse-road past the Coffin Stone,
then curved through a mixed copse to a scree path
scored by rainwater into the hill's back.
I was hauled upwards by a borrowed dog
on a makeshift leash, a yellow Labrador
gunning for every birdcall and blown leaf.
Over a hand-stacked wall, in the next fold,
under the driftwood bones of a late elm
a red deer had dropped down from the fell
with morning beaconed in its flaming horns.
With dawn-light cradled in its branching crown.
I stood in some blind-spot of its dark eye
and deer and dog were still and unaware
and stayed that way, divided by the wall:
wild stag and hunting hound in separate worlds,
before the deer pushed on through tinder thickets,
igniting the next field. And the dog yawned.
Then I hacked up the ghyll to higher ground
counting the hikers striding along the ridge,
thinking of taking a drink from the tarn,
thinking of adding a new stone to the cairn.

The Candlelighter, The Unaccompanied, Simon Armitage
Faber & Faber Ltd copyright © Simon Armitage

*Simon Armitage was Professor of Poetry at the University
of Oxford 2015-2019. He is now Professor of Poetry at the
University of Leeds, and the current national Poet Laureate
(2019-2029).*

Right: Above Dove Cottage, Grasmere

POLLY ATKIN

Commonality

There is one crag – the highest and largest of the common's sleeping trolls – that gives a panoramic view of both Grasmere and Rydal. For a long time I avoided it because I thought it was too hard for me to climb alone, that there was too much risk of falling. Now I know the easy ways up, and down. It is low enough and high enough that you can see both lakes, and down both valleys. The angles implausible. Its sides fall into slopes and terraces that feel both man-made and geologic. The top is flat, a natural or unnatural stage – a boggy centre surrounded by a walkway of stone. It feels purposeful. An ancient fort or settlement.

There is an uncanny feeling there – both peaceful and watchful – that it was occupied a very long time ago, and is occupied still. Every time I sit there, on one of the perfect seats formed from the rock, I think I might never be able to turn my eyes away and leave. Dorothy Wordsworth wrote about the light there, the strangeness of the perspective: 'There was a strange Mountain lightness when we were at the top of the White Moss. I have often observed it there in the evenings, being between the two valleys. There is more of the sky there than any other place. It has a strange effect sometimes along with the obscurity of evening or night. It seems almost like a peculiar sort of light.'

This extract is from a piece called Commonality *which was commissioned by PLACE 2020, the centre for Place Writing at Manchester Metropolitan University. Polly Atkin is an award-winning published poet, writer and academic who lives in Grasmere. She teaches creative writing and poetry.*

The view from Loughrigg towards Grasmere on the right and the Langdale Pikes in the distance.

MARGARET FORSTER

My Life in Houses

We walked, we climbed, and we swam. The lake was where we spent our afternoons whenever there was hot weather, taking a picnic down to the tiny pebble beach known as Sandy Yat. 'Yat' means 'gate', and a gate is still there, but if there was ever sand it has long since been washed away. The view from Sandy Yat is of the whole of Crummock Water stretching away to Buttermere, an expanse of water which, on still days, is literally like a mirror, reflecting perfectly the fells all around. Going into it to swim, the aim was not to shatter these reflections, to swim so carefully that in spite of a slight ripple on the surface they were undisturbed. It was as if we were moving not through water but through hills.

Once, on such a day, I got up before dawn and slipped out of the house – I felt it held its breath for me – and walked rapidly along the side of Melbreak to Buttermere so that by the time the sun was up I was climbing Red Pike and stood on the summit by nine o'clock with the sun bouncing off the lake below in a million tiny lights as it hit the water. There was the sensation, standing alone there, of being completely insubstantial, of having no place amid all this natural glory, of disappearing into the landscape. I thought how satisfying it would be, when the time came to die, to die in such a place, just melting into the rocks. It wasn't a morbid thought at all, but quite the opposite. Then I came down and swam from Ling Crag.

My Life in Houses, Margaret Forster, Chatto & Windus, 2014
Permission from Penguin Random House UK © Margaret Forster

Margaret Forster, author, biographer and historian, and her husband, Hunter Davies, owned a house in Loweswater village for nearly thirty years where they would spend the summer months each year.

Photo: Crummock Water

H. V. MORTON

In Search of England

I will not dare to compare the soft beauty of Windermere with the majesty of Derwentwater or the grand solitude of Ullswater, or the high serenity of Thirlmere and Coniston. If I have any preference it is for the smallest of them all: little Rydal Water, which is three-quarters of a mile long and, beside these watery giants, is just a spoonful of blue in a cup of green hills. Rydal Water is a magic, satisfying lakelet – a little looking-glass in which the woody heights, by which it is hemmed, lie as in a mirror.

I saw it first at night. It was a clear, moonlit night, with no breath of wind among the trees. In the middle of the little lake, round and golden as a guinea, lay the moon. Sights such as this, hiding round a corner, lurking behind trees and suddenly revealed, pull a man up sharply and fling him on his knees. Had Rydal Water been in Cornwall or in Wales nothing could have disconnected it from the Excalibur legend; and most men would have believed it, for this is a mystic mere…

As I looked, a water-fowl, surprised among the dark reeds, flew noiselessly over the lake in the night, its little feet just tearing a thin silver line in the water. The moon danced up and down once or twice; then the lake composed itself, and went on dreaming.

In Search of England, H. V. Morton
Methuen & Co Ltd, 15th Ed., 1931

H V Morton was a journalist and travel writer between the wars. His series of newspaper articles about his travels around England in his bullnose Morris became a best seller when published as In Search of England.

Left: Rydal Water

DAVID HOWE

Rocks and Rain, Reason and Romance

The trade in greenstone axes began to bring relative wealth to the area. Throughout the ages the rich and powerful have been wont to flaunt their success by building big. Pyramids, triumphal arches, steeples, towers, skyscrapers – the tallest buildings often tell us who were the most powerful people in that age. Ancient pharaohs and kings built their pyramids and palaces. Medieval bishops and popes raised churches and cathedrals, spires and steeples. And in our own age, bankers and financiers commission thrusting skyscrapers and glassy towers.

Well, Neolithic chiefs might not have been able to build quite so big and tall, but wealth and prestige allowed them to build big and round. Late Stone Age Cumbria has a surprisingly large number of stone circles and henges. …

Perhaps the most distinctive and evocative stone circle is the one sitting atop Castlerigg, just south of Keswick. The setting is glorious. The grassy plateau lies in the centre of a vast, mountainous amphitheatre. As you stand in the middle of the stones and slowly pan round you see High Seat, Helvellyn, Blencathra, Skiddaw, and in the distance, Scafell Pike. There is a sense of the sublime. I'm here on another wild, windy day. The broiling clouds, low and grey, tumble and swirl. For a mad moment I imagine I'm conducting the heavens as they rage in nebulous frenzy around and above my head.

Rocks and Rain, Reason and Romance: The Landscape, History and People of the Lake District,
David Howe, Saraband, 2019 © David Howe 2019, reproduced with permission of Saraband.

David Howe describes how the geology of the area has shaped this dramatic landscape and tightly woven the lives of its people to those inspiring lakes and fells.

Photo: Castlerigg Stone Circle

JAMES REBANKS

The Shepherd's Life

When I leave my flock in the fells surrounded by grass and come down home, I leave something of myself up there with them. So I look away to the skyline where they graze several times a day. Sometimes I can't help myself, and go back up the fell just to see that all is well. The skylarks ascend, singing, disturbed by my boots and the sheepdogs.

The sheep's evident satisfaction at being back where they feel at home means that winter and spring are fast receding behind us. The fell sheep can largely look after themselves in the coming weeks. So I lie down by the beck and cusp out a handful of water. I slurp it. There is no water tastes so sweet and pure.

Then I roll over on my back and watch the clouds racing by. Floss lies in the beck, cooling off, and Tan nuzzles into my side, because he has never seen me lazing about. He has never seen me stop like this. He has never seen summer before.

I breathe in the cool mountain air. And watch a plane chalking a trail across the blue of the sky.

The ewes call to the lambs following them as they climb up the crags.

This is my life. I want no other.

The Shepherd's Life: A Tale of the Lake District, James Rebanks
Allen Lane, 2015. Permission granted by Penguin Random House.

James Rebanks farms in Matterdale, where his family has farmed for 600 years. Powerful and unsentimental, yet beautiful and moving, The Shepherd's Life *tells of his family, their work and way of life, the land in which they are so strongly rooted, and their need to care for it to ensure its and their survival.*

Left: Herdwick sheep grazing on the nearby hills of Ullswater

NORMAN NICHOLSON

Wall

The wall walks the fell –
Grey millipede on slow
Stone hooves;
Its slack back hollowed
At gulleys and grooves,
Or shouldering over
Old boulders
Too big to be rolled away,
Fallen fragments
Of the high crags
Crawl in the walk of the wall.

A dry-stone wall
Is a wall and a wall,
Leaning together
(Cumberland-and-Westmorland
Champion wrestlers),
Greening and weathering,
Flank by flank,
With filling of rubble
Between the two–
A double-rank
Stone dyke:
Flags and through-
stones, jutting out side-ways,
Like the steps of a stile.

A wall walks slowly.
At each give of the ground,
Each creak of the rock's ribs,
It puts its foot gingerly,
Arches its hog-holes,
Lets cobble and knee-joint
Settle and grip.
As the slipping fellside
Erodes and drifts,
The wall shifts with it,
Is always on the move.

They built a wall slowly,
A day a week;
Built it to stand,
But not to stand still.
They built a wall to walk.

'Wall', *Collected Poems*, Norman Nicholson, Faber & Faber, London

Norman Nicholson was a very well-known Cumbrian poet, novelist and playwright whose work was closely associated with his hometown of Millom and the surrounding area.

Above: Causey Pike and the Derwent Fells from Castlerigg

RICHARD ADAMS

The Plague Dogs

What place in all the Lakes can surpass, in grandeur and beauty, the summit of Wreynus Pass and the high solitude of the Three Shire Stone? Where, if not here, is to be found the heart of the Lakeland – here, where the northern shoulder of the Coniston range meets the southern tip of the great Scafell horseshoe, and Langdale reaches up its arms to Dunnerdale across this desolate band of rock, turf and ling? Stand, reader, here – by the long stone itself, if you will, or at the summit of the pass – at dawn on a June morning, or at dusk of a rainy November nightfall. What, in the emptiness, do you hear, listening with closed eyes and fingers resting upon the squared edge of the stone? Nothing that you would not have heard a thousand years ago. Down the long, bare ridges on either side sounds the wind, tugging in uneven gusts over the slopes, breaking, as strongly as round a cathedral, about the corners of the greater crags that oppose their masses to its force. Up from below – from before and behind you – wavers the distant sighing of the becks, the sound coming and going on that same wind; and the occasional cry of hawk, buzzard or crow sailing on the currents in obedience to behavioural instincts evolved tens of thousands of years gone by.

The Plague Dogs, Richard Adams
© Allen Lane, Penguin Books Ltd, 1977
Reproduced with permission of the Licensor through PLSclear

This novel by Richard Adams, author of Watership Down, *describes how two dogs escape a research station in the Lake District where they have been cruelly mistreated and their struggles to survive in the wild.*

Left: Wrynose Pass

MARIE-ELSA BRAGG

Towards Mellbreak

Over the far side of Crummock Water Stephen's mind refuses the presence of Red Pike, pushing the purple grey, as if there were lakes on either side of him. When he gets to Blea Crag the light changes and his steps quicken towards Mellbreak as the valley opens between them. Pools of sun circle a log or bank as if it's held. The bark of a tree is warmed to the side so that it leans in peace.

By afternoon, clouds have covered the skies, to part again in the nook between the twin fells. Veins of bronze lengthen into straight, certain lines, reminding the valley it is marked. Stephen rests by the tall juniper, a silver birch partly entwined. He throws a large stick into the lake and watches Hemp's white nose and black ears bob after it. His arm begins to cramp so he walks the valley, luscious in its meadow mint, dandelions, forget-me-nots, speedwell and buttercups; their colours pulling him this way and that, catching the sun.

Towards Mellbreak, Marie-Elsa Bragg
Chatto & Windus/Penguin Random House, 2017

With beautiful descriptions of the surrounding landscape, this novel tells the story of a farming family and the terrible consequences of their old ways having to change.

Left: Summer fields, Buttermere

JOHN WYATT

Reflections on the Lakes

I was once leading a party of Londoners from Helvellyn over Dollywaggon in mist and rain and strong wind. The struggle with the elements had been a great disappointment to them. They had had dull misty weather for the several days of their stay. They had looked forward for weeks to the fell walk, and after leaving the cars in Patterdale they had seen nothing. Helvellyn, but for the exertion of the climb and the last scramble to the ridge, might have been Box Hill. Then as we approached Dollywaggon's southerly descent the rain ceased and the mist in front of us glowed a pale yellow.

I knew what was coming, the others did not. I heard the song, first the soft whisper of it, the muted harmonies, then the drum-beats, growing, growing – swelling. Then with a great crash the mighty orchestra burst forth to a crescendo

at the dramatic sweep of the Almighty's baton – the curtain of mist was plucked savagely back and tore above our heads as the great trumpet-roar of the wind struck us. Suddenly out of obscurity there was the almost painfully vivid view of the flank of Fairfield, golden with sunshine and animated with racing cloud shadows, and dizzily far below at our feet, the grey-blue waters of Grisedale Tarn, whipped with white furrows. The great anthem roared out to us – 'Glory! Alleluia!'

A shout of surprise came from my party and it was not just the wind that made them sit down; the experience left them powerless to move. One of us lost a hat. I swear it was thrown in the air!

Reflections on the Lakes, John Wyatt, W H Allen & Co Ltd, London, 1980

John Wyatt was the first warden of the Lake District National Park and, for the first two years, covered the entire area on his own. In Reflections on the Lakes, *he describes his everyday tasks of looking after this area of overpowering beauty, its inhabitants and visitors.*

Above: Dollywaggon Pike, Grisedale Tarn, St Sunday Crag and Fairfield

ROBERT SOUTHEY

Waterloo Celebrated, 1815

Keswick, August 23, 1815

Monday, the 21ˢᵗ of August, was not a more remarkable day in your life than it was in that of my neighbour Skiddaw, who is a much older personage. The weather served for our bonfire, and never, I believe, was such an assemblage upon such a spot. To my utter astonishment, Lord Sunderlin rode up, and Lady S., who had endeavoured to dissuade *me* from going as a thing too dangerous, joined the walking party. Wordsworth with his wife, sister, and eldest boy, came over on purpose. James Boswell arrived that morning at the Sunderlins. Edith, the Senhora, Edith May, and Herbert were my convoy, with our three maid-servants, some of our neighbours, some adventurous lakers, and Messrs. Rag, Tag, and Bobtail, made up the rest of the assembly.

We roasted beef and boiled plum-puddings there; sang 'God save the King' round the most furious body of flaming tar-barrels that I ever saw; drank a huge wooden bowl of punch; fired cannon at every health with three times three, and rolled large blazing balls of tow and turpentine down the steep side of the mountain. The effect was grand beyond imagination. We formed a huge circle round the most intense light, and behind us was an immense arch of the most intense darkness, for our bonfire fairly put out the moon.

Waterloo Celebrated, 1815, Robert Southey (Letter to his brother)

Robert Southey, then Poet Laureate, clearly had a great time having a picnic along with Wordsworth and his family and friends at the top of Skiddaw to celebrate Wellington's victory.

Right: Sunset over Skiddaw

KEN HUGHES

High Wray

The rest of the afternoon passed peacefully by, although I was conscious all the time of a tense underlying atmosphere of expectancy. It was rather like tightening the E string of a violin and waiting for it to break. Bev sat with his feet dangling in the water, watching my efforts with a rod and line with quiet amusement, while Carol lay stretched out on the roof of the cabin in what passed for a bathing costume, but what I suspected was a pocket handkerchief. We drank whisky out of paper cups, and stared hopefully at the celluloid floats bobbing on the water. The fish bit and got away, the boat teetered contentedly to and fro like an old rocking-chair, and the water lapped dully against the hull. Every now and again

we would raise our hands at some passing yacht or ferry and, in order to conserve our energy, would in the same movement reach out for the bottle of whisky.

I am quite prepared to discover that St. Peter's function at the Golden Gates is to hand every newcomer a rod, a line, and a bottle of whisky, and that on the other side of the Gates will be a vast, placid lake dotted with celestial vessels, and in them will be people fishing.

High Wray, Ken Hughes, Thriller Book Club edition, London, 1952

In this 1950s thriller, the author describes Wray Castle, now owned by the National Trust. It is a Victorian neo-gothic building on the shores of Windermere; when Beatrix Potter and her family first visited the Lakes in 1882, they stayed at this house. The book was made into a film, The House Across the Lake, *which was directed by the author, Ken Hughes.*

Above: Wray Castle, Windermere

CHARLIE LAMBERT

Visibility

Is it a path,
or a beck?
Are we climbing,
or tumbling?
Cairn? Or simply stones?
Cloud? Or mist?

The compass dithers
and the trig point
lurks damply
within the mist.
Winterbrown bracken
slopes across the crag
and black marshes suck
our footsteps backwards.

Then it comes without a sound
without a movement
without a sign
or a breath.
The veil parts,
and far below,
below the bracken
and the becks,
three hundred feet below,
the lake appears,
and silver streaks illuminate
the steel grey surface,
always changing,
changing yet permanent,
seen, or unseen.

'Visibility', Charlie Lambert
This Place I Know, *A New Anthology of Cumbrian
Poetry*, Handstand Press, Sedbergh, 2018

Left: Glenridding, Ullswater

WILLIAM WORDSWORTH

From The Prelude, Book 1

One evening (surely I was led by her)
I went alone into a Shepherd's Boat,
A Skiff that to a Willow tree was tied
Within a rocky Cave, its usual home.
'Twas by the shores of Patterdale, a Vale
Wherein I was a Stranger, thither come
A School-boy Traveller, at the Holidays.
Forth rambled from the Village Inn alone
No sooner had I sight of this small Skiff,
Discover'd thus by unexpected chance,
Than I unloos'd her tether and embark'd.
The moon was up, the Lake was shining clear
Among the hoary mountains; from the Shore
I push'd, and struck the oars and struck again
In cadence, and my little Boat mov'd on
Even like a Man who walks with stately step
Though bent on speed. It was an act of stealth
And troubled pleasure; not without the voice
Of mountain-echoes did my Boat move on,
Leaving behind her still on either side
Small circles glittering idly in the moon,
Until they melted all into one track
Of sparkling light. A rocky Steep uprose
Above the Cavern of the Willow tree
And now, as suited one who proudly row'd
With his best skill, I fix'd a steady view
Upon the top of that same craggy ridge,
The bound of the horizon, for behind
Was nothing but the stars and the grey sky.
She was an elfin Pinnace; lustily
I dipp'd my oars into the silent Lake,
And, as I rose upon the stroke, my Boat
Went heaving through the water, like a Swan;
When from behind that craggy Steep, till then
The bound of the horizon, a huge Cliff,
As if with voluntary power instinct,

Uprear'd its head. I struck, and struck again
And, growing still in stature, the huge Cliff
Rose up between me and the stars, and still,
With measur'd motion, like a living thing,
Strode after me. With trembling hands I turn'd,
And through the silent water stole my way
Back to the Cavern of the Willow tree.
There, in her mooring-place, I left my Bark,
And, through the meadows homeward went, with grave
And serious thoughts; and after I had seen

That spectacle, for many days, my brain
Work'd with a dim and undetermin'd sense
Of unknown modes of being; in my thoughts
There was a darkness, call it solitude,
Or blank desertion, no familiar shapes
Of hourly objects, images of trees,
Of sea or sky, no colours of green fields;
But huge and mighty Forms that do not live
Like living men mov'd slowly through the mind
By day and were the trouble of my dreams.

This extract describes how the young Wordsworth took a shepherd's boat to row at night on Ullswater. However, his enjoyment of the beauty of the moonlight on the water turns to fear as the looming mountains overwhelm him; this power of Nature continues to haunt him long after he has returned the boat.

Above: Langdale Pikes, Lingmoor and Windermere

Above: Nethermost Pike from the Hole in the Wall path to Helvellyn

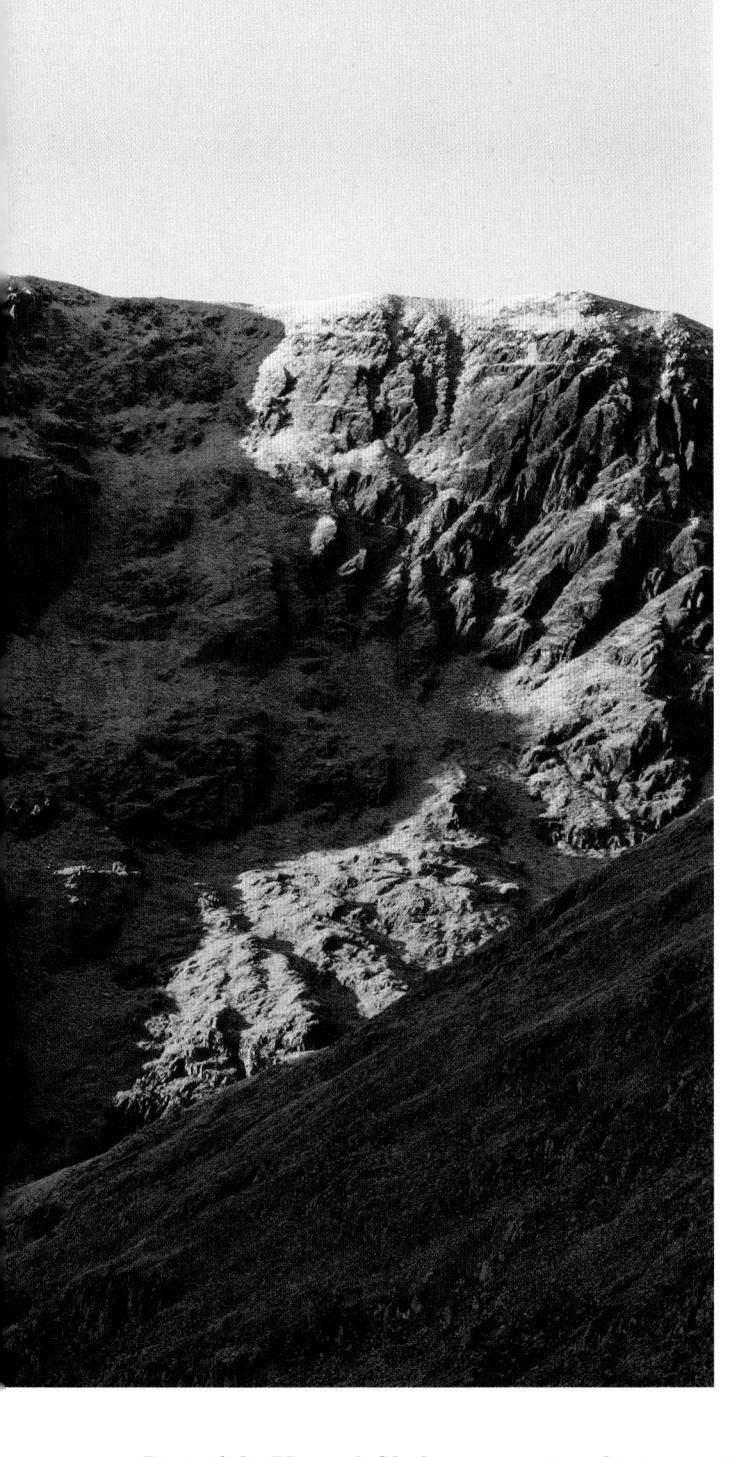

EDWARD ST AUBYN

Dunbar

As the ground flattened out, he came to a halt, arrested by an unexpected scene. The source of the stream, it turned out, was a small circular lake beneath the final ascent. Just to the left of the path, on the near side of the lake, was a perfect little beach, a natural resting place and contemplative opportunity, coated with snow. The water itself was covered in a thin, opaque sheet of ice, except where the pull of the stream kept it dark and liquid. A curved escarpment rose abruptly from the far shore, like a headdress on the brow of the lake.

Dunbar found it piercingly beautiful, almost too beautiful, as if it had been choreographed for an exquisite death, a role that must have been reserved for him, since there was no one else for miles around. He hurried on superstitiously, like a pregnant woman who crosses herself as she realises she is walking next to a cemetery wall, moving as fast as he dared over stones slippery with snow. The path circled the lake and then merged with the pass, which was now entirely in shadow.

Only the very top of the mountain on the far side of the pass was still sometimes lit up with a splash of cold gold light.

Dunbar, Edward St Aubyn, Vintage/Penguin Random House, London, 2018

Part of the Hogarth Shakespeare series, this is a re-imagining of King Lear. Henry Dunbar has passed his global business empire on to his two greedy, ambitious older daughters who have promptly shut him up in a care home in the Lakes from which he escapes into the hills.

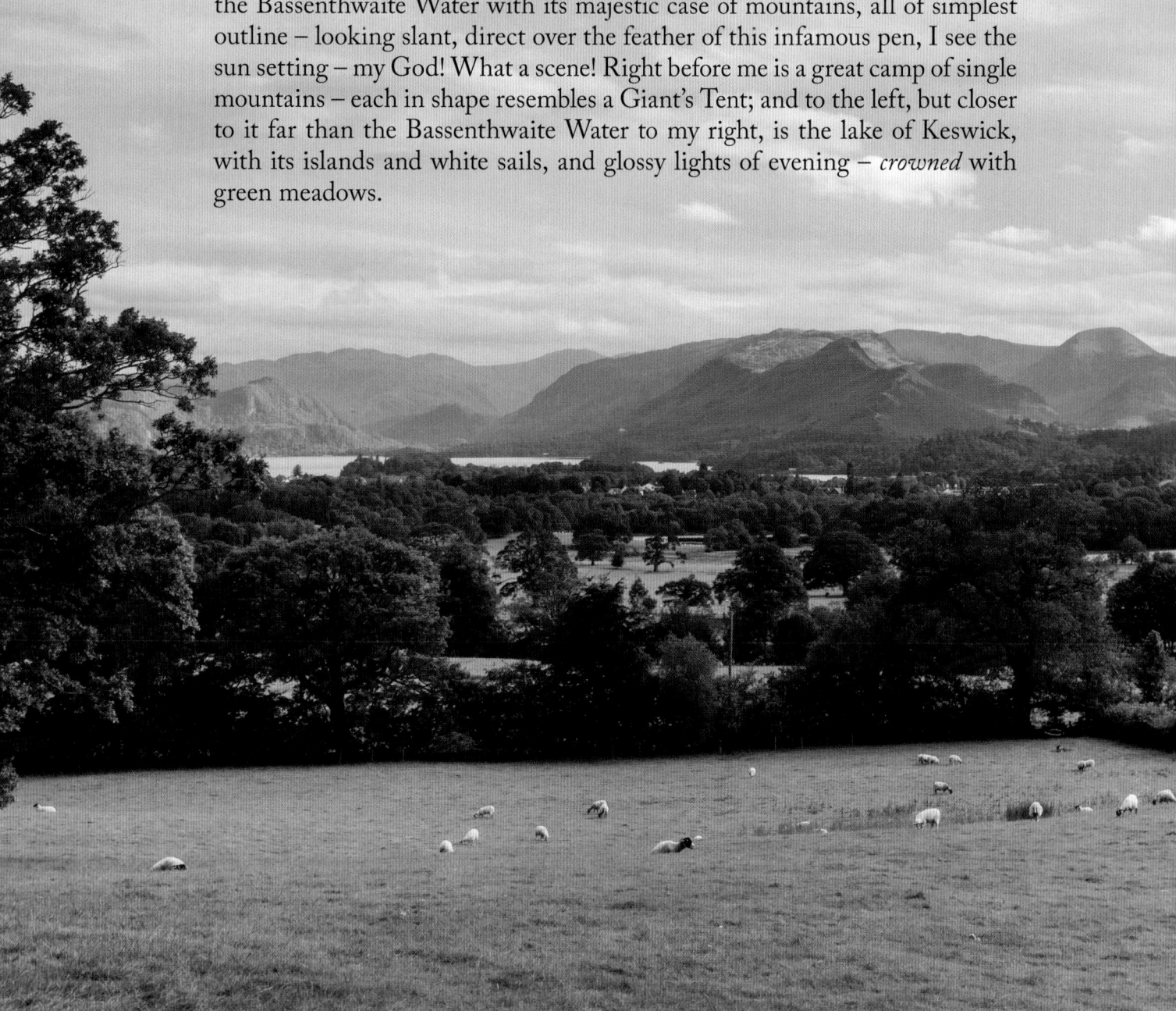

SAMUEL TAYLOR COLERIDGE

Letter to Samuel Purkis

Keswick, 29 July 1800

Yes – my dear Sir! here I am – with Skiddaw at my back – on my right hand the Bassenthwaite Water with its majestic case of mountains, all of simplest outline – looking slant, direct over the feather of this infamous pen, I see the sun setting – my God! What a scene! Right before me is a great camp of single mountains – each in shape resembles a Giant's Tent; and to the left, but closer to it far than the Bassenthwaite Water to my right, is the lake of Keswick, with its islands and white sails, and glossy lights of evening – *crowned* with green meadows.

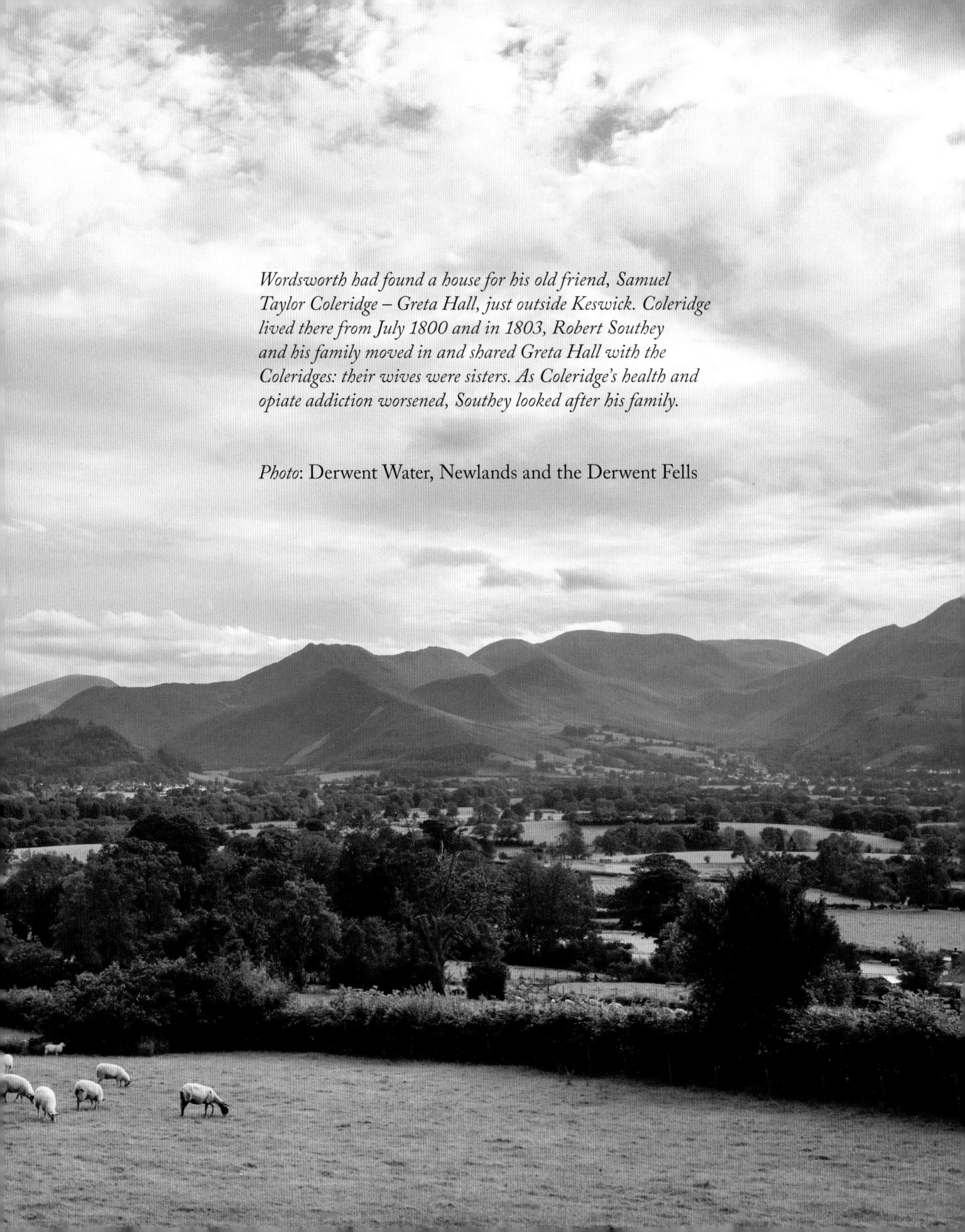

Wordsworth had found a house for his old friend, Samuel Taylor Coleridge – Greta Hall, just outside Keswick. Coleridge lived there from July 1800 and in 1803, Robert Southey and his family moved in and shared Greta Hall with the Coleridges: their wives were sisters. As Coleridge's health and opiate addiction worsened, Southey looked after his family.

Photo: Derwent Water, Newlands and the Derwent Fells

JOHN PEPPER

Cockley Beck

Here, real mountains reared and thunder skulked. A large dammed tarn, a mountain lake, sat brooding under fierce ink screes. A timeless place where the old ways and words lingered still; language, either in the stillness of the mind or from the tongues of old dalesmen, like the sounds of frost in walls. The sort of country no plough could get at for long, so its summertimes were among the last havens of rare flora; orchids in woodland hints of velvet, the delicate monkey flower in splashes of red and yellow by limpid stream… and moist groves the haunt of scrumptious fungi such as the elf's-ear chanterelle smelling of apricots and tasting like nuts.

Finally, at the apex of it all, in the giant ice-cream scoop of rock where one might expect to stumble on witches rather than civil beings, loomed our peeling white farm and humpback bridge of Cockley Beck. Once, there had been a holding higher still, in the northern pass; but life there had finally been ground down and all that remained today was legends; stones.

Over it all, in winter especially, lay a silence that sang.

Cockley Beck: A Celebration of Lakeland in Winter
John Pepper, Element Books, 1984; Sutton 2006

For ten years, John Pepper spent each winter in a tiny cottage in search of a simple way of life. His description of the surrounding glorious wilderness was described by The Guardian *as one of 'the great classics of British nature writing'.*

Above: Cockley Beck and Wrynose Bottom

JOHN RICHARDSON

It's nobbut me

Ya winter neet, I mind it weel,
 Oor lads 'ed been at t'fell,
An', bein' tir't, went seun to bed,
 An' I sat be mesel.
I hard a jike on t'window pane,
 An' deftly went to see;
Bit when I ax't, 'Who's jiken there?'
 Says t'chap, 'It's nobbut me.'

'Who's *me*?' says I, 'What want ye here?
 Oor fwok ur aw i'bed' –
'I dunnet want your fwok at aw,
 It's *thee* I want,' he sed.
'What cant'e want wi' me,' says I;
 'An' who, the deuce, can't be?
Just tell me who it is, an' than' –
 Says he, 'It's nobbut me.'

'I want a sweetheart, an' I thowt
 Thoo mebby wad an' aw;
I'd been a bit down t'deal to-neet,
 An' thowt 'at I wad caw;
What, cant'e like me, dus t'e think?
 I think I wad like thee' –
'I dunnet know who 't is,' says I,
 Says he, 'It's nobbut me.'

We pestit on a canny while,
 I thowt his voice I kent;
An' than I steal quite whisht away,
 An' oot at t'dooer I went.
I creapp, an' gat 'im be t'cwoat laps,
 'Twas dark, he cuddent see;
He startit roond, an' said, 'Who's that?'
 Says I, 'It's nobbut me.'

An' menny a time he com agean,
 An' menny a time I went,
An' sed, 'Who's that 'at's jiken theer?'
 When gaily weel I kent:
An' mainly what t'seamm answer com,
 Fra back o' t'laylick tree;
He sed, 'I think thoo knows who't is:
 Thoo knows it's nobbut me.'

jike = scratch; **pestit** = chatted; **whisht** = quiet

It's twenty year an' mair sen than,
 An' ups an' doons we've hed;
An' six fine barns hev blest us beath,
 Sen Jim an' me war wed.
An' menny a time I've known 'im steal,
 When I'd yan on me knee,
To mak me start, an' than wad laugh –
 Ha! Ha! 'It's nobbut me.'

Below: Bridge House, St John's in the Vale

It's nobbut me, Cummerland Talk John Richardson
John Russell Smith, London, 1871

*John Richardson (1817–1886) was born at Naddle,
near Keswick. He was a stone mason and was
involved in rebuilding the church of St John's in the
Vale and the church school, where he later became
the teacher. He was also a poet and writer who
often wrote in Cumbrian dialect. This poem is said
to be based on his courtship of his wife, Grace.*

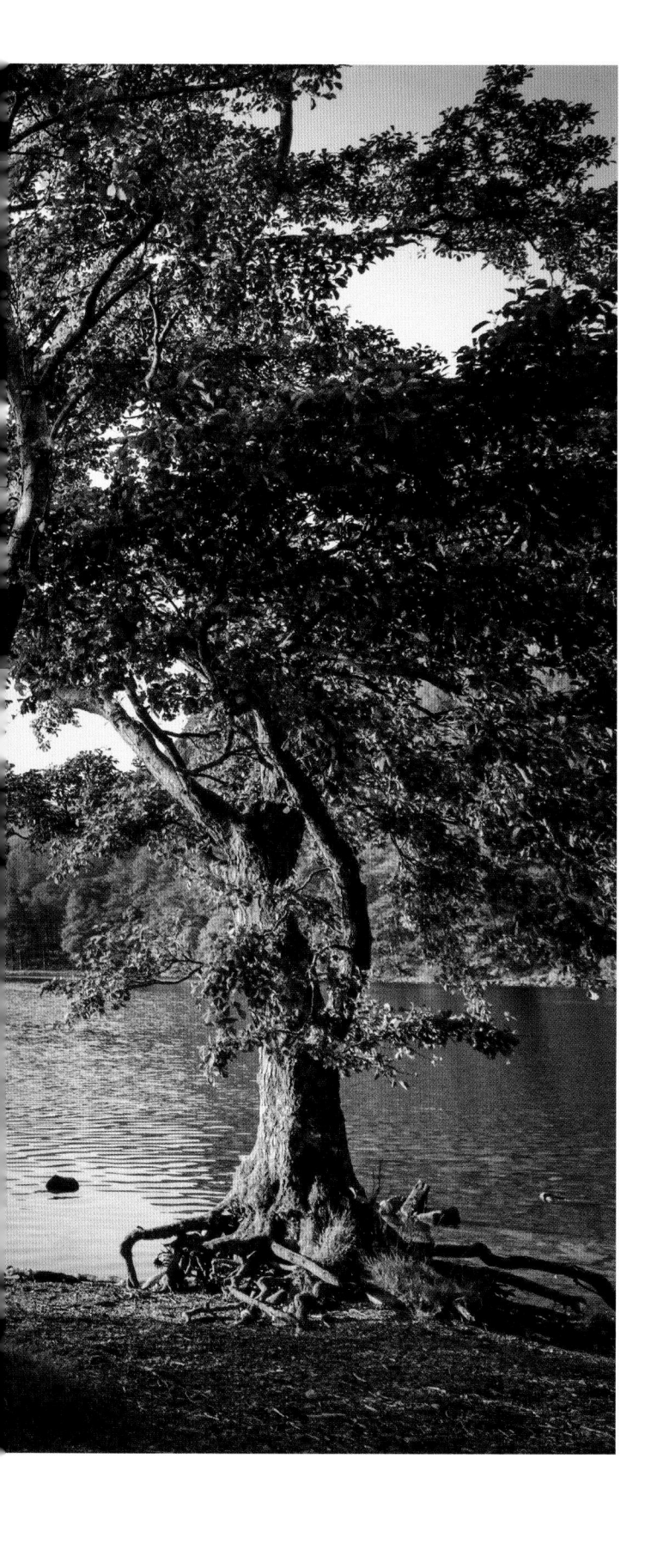

JACKIE HUCK

This Land of Lakes

It's that wake of the dawn
 when a slow morning stirs
as the silver and blue turn to gold,
when the sun hauls itself up
 the back of the fells
and the deep darkling shadows unfold.

It's the white whip of winter
 that ices the tops, which claws
down the gullies and screes,
where the image is trapped
 on the bowl of a lake
along with a few million trees.

Or it could be the fury
 of gales through the gorse,
the cold hug of mist everywhere,
as it swarms through the valleys
 and over the peaks leaving
cool ghostly clouds in the air.

Or is it the flare from
 a flame-flooded sky that streams
into crevice and stone,
as invisible strands bind
 this land to your soul
and its splendour calls you back home.

'This Land of Lakes', Jackie Huck
This Place I Know, *A New Anthology of Cumbrian Poetry*, Handstand Press, Sedbergh, 2018

Left: Buttermere and Fleetwith Pike

IRVINE HUNT

The Charcoal Burners

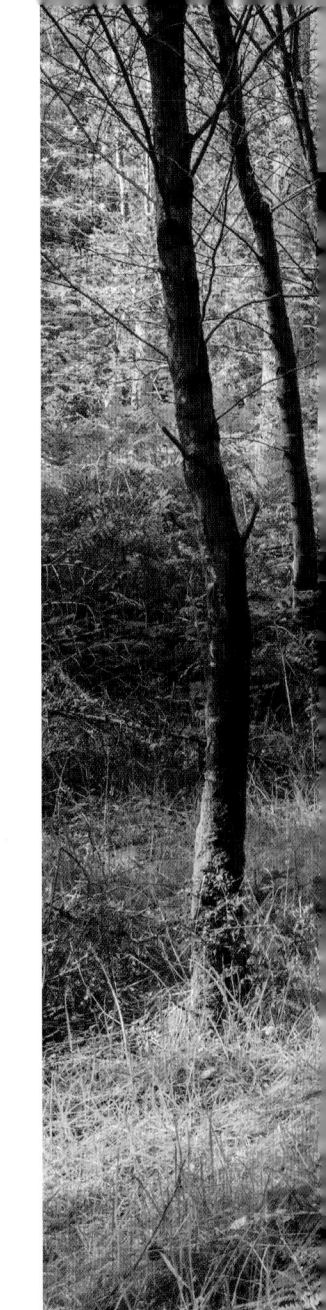

Soon after dawn the men and carts arrive
and horses, fresh uncreaked from night's sleep,
stand sorrow-eyed within the wood.
The charcoal pit lies derelict and deep in fern;
the burners' hut a sagging den; and piles of wood,
stacked months before, overgrown in tangled grass,
seeming waste, but by these woodmen known and understood.

It hardly seems a place for toil, yet soon
the rough is cleared, and in among the sapling trees
the burners' axes chop and cut. By ten, the hut is
fresh repaired and on a fire a blackened kettle steams.

The burners toil steadfastly,
setting saplings on the mound until it stands,
a passive lump, the wood entombed within the turf,
and wind among the trees around keening softly
as if it knows that each axe blow means death for each shorn stump.

At noon next day the waiting mound is fired.
Hot coals stream within its heart
and when the inner crack of singing wood is heard,
the final sealing turf is laid.
And muttering and crackling, the mound takes on a life
that's all its own, reeking smoke and steam
and uttering half-heard thoughts
of bowers where the light runs green
and endless glades of sun
and forests by the sea.

All night and all next day the charcoal men
nurse the smouldering mound,
pouring earth on spurts of flame,
splashing water from the beck,
damping flames and snatching sleep
as best they may, on bracken-beds and turf.

For three long days and nights the smell of burning wood,
and then the fire seems to die.
The smoke is gone, but all there know
the embers still glow bright within.
And suddenly tired men regain their drive
as in each mind the thought prevails:
Has it worked; has the burn gone well?

Slowly, the cooled mound is turned back.
The tired burners smile. The prize, the charcoal,
glistens satin-black, and rings... clear as a bell.

'The Charcoal Burners' Irvine Hunt
from *The Lake District: An Anthology*
Robert Hale Ltd, London, 1977

*During the Victorian and Edwardian
eras woodlands across Lakeland were
busy with charcoal burning. It is a lengthy
process and the men would build circular
huts to stay in, the stone bases of which can
still be found in some areas.*

Above: Haverthwaite Heights

CHRIS BONINGTON

Ascent

Inevitably I wanted to share my love of climbing with the boys. Joe had no fear of heights and thoroughly enjoyed it. I took him up the classic route *Little Chamonix* on Shepherd's Crag in Borrowdale when he was ten, not so difficult but with an awkward step that is intimidating for a second and a spectacular top pitch. Joe coped with aplomb.

I remember too a day on Gillercombe, also in Borrowdale. We took along Bodie, short for Boadicea, our crossbreed who combined sheepdog, Alsatian, a bit of lurcher and goodness knows what else. She was a nimble climber and I often left her at the bottom of a crag.

While I climbed, Bodie would go round the side and meet me at the top. But on Gillercombe that day, Bodie decided to traverse across the crag along heathery ledges to where I was belaying Joe up the cliff. I couldn't get both of them up the route, and I only had a couple of slings around my neck, so I tied the dog to Joe with the slings and took a diagonal line up across the heather and broken rocks to get us off the crag. If Joe had slipped, or for that matter Bodie, they would both have taken a massive pendulum but Joe kept very cool and we all escaped without further incident.

Ascent Chris Bonington, Simon & Schuster UK Ltd, London, 2017

British mountaineer Sir Chris Bonington has lived for many years in Cumbria; he and his wife brought their boys up there.

Right: Two climbers (in red) scaling Shepherd's Crag in Borrowdale

THOMAS DE QUINCEY

Twice, as I have said, did I advance as far as the Lake of Coniston; which is about eight miles from the church of Grasmere, and once I absolutely went forwards from Coniston to the very gorge of Hammerscar, from which the whole Vale of Grasmere suddenly breaks upon the view in a style of almost theatrical surprise, with its lovely valley stretching before the eye in the distance, the lake lying immediately below, with its solemn ark-like island of four and a half acres in size seemingly floating on its surface, and its exquisite outline on the opposite shore, revealing all its little bays and wild sylvan margin, feathered to the edge with wild flowers and ferns. In one quarter, a little wood, stretching for about half a mile towards the outlet of the lake; more directly in opposition to the spectator, a few green fields; and beyond them, just two bowshots from the water, a little white cottage gleaming from the midst of trees with a vast and seemingly never-ending series of ascents, rising above it to the height of more than three thousand feet. That little cottage was Wordsworth's from the time of his marriage, and earlier; in fact, from the beginning of the century to the year 1808. Afterwards, for many a year, it was mine. Catching one hasty glimpse of this loveliest of landscapes, I retreated like a guilty thing, for fear I might be surprised by Wordsworth, and then returned faintheartedly to Coniston, and so to Oxford, *re infecta*.

Recollections of the Lakes and the Lake Poets, Thomas de Quincey, Adam & Charles Black, Edinburgh, 1863

Thomas de Quincey, essayist and best known for Confessions of an English Opium-Eater, *travelled twice to the Lakes, hoping to meet Wordsworth but twice his courage failed him before he finally succeeded while travelling with the Coleridges.*

Left: Looking down on Grasmere from Loughrigg

NICHOLAS SIZE

The Secret Valley

By bitter experience the Normans had learned a good deal about Lakeland, and now had a clear idea of the position of the secret valley which they were so anxious to attack. No Norman had ever seen it, and there were fantastic legends of its position high up among the mountain tops, or walled in by extraordinary barriers; also there were tales of its invisibility and of the enchantments which surrounded it.

The extraordinary losses of the Norman armies were superstitiously put down to reasons of this kind, and as there was little real information, the most horrible stories were believed by the soldiers concerning the disappearance of their comrades apparently carried off by demons.

The Secret Valley: The real romance of unconquered Lakeland Nicholas Size. First published 1930, reprinted Llanerch Publishers, Felinfach, 1996

The Secret Valley *tells the story of how the Norse settlers and people of Lakeland held out for half a century against the Norman conquerors. The headquarters of the resistance were hidden in the upper part of Rannerdale valley.*

Right: Rannerdale Knotts

OWEN GLYNNE JONES

Rock-climbing in the English Lake District

The Christmas Day of 1896 was very windy and cold. Our party had fought continually against the weather all the way to Deep Ghyll, and inasmuch as we had only the previous day arrived at Wastdale our limbs were scarcely fit for such a desperate grind. I had the pleasurable responsibility of guiding a lady, Mrs. H., who had been persuaded to accompany her husband on a winter excursion. We had a great deal of very soft snow to get through on our way up, and I was looking forward to a long halt in the lower cave, where we should at least be protected from the wind and snow. Great was our distress when we found the entrance completely blocked up by a huge drift. It must have been fully twenty feet deep in front of the cave, and the prospect was most disheartening.

In disgust I clambered up the wall immediately to the right of the boulder, and at last managed to reach the aperture leading into the cave from above. It was festooned with huge icicles, and at first the entrance looked effectually blocked. Smashing down the ice with the energy of despair, the tremendous clatter suggesting to my friends that of a bull in a hardware shop, I discovered that the chimney was only iced by its entrance, and that the upper storey of the cave could be reached.

Some of the others quickly followed, and we found ourselves in a spacious chamber into which the great heap of snow had scarcely encroached. This was delightful. We threw ourselves into the drift that blocked the main entrance, and cut away at it with vigour till at last we had tunnelled through to the daylight. The biggest man of the party yet remained outside and we persuaded him to insert his legs into the aperture. Without giving him time to change his mind we seized his boots and hauled hard. For one dread moment we thought him jammed for ever, but immediately afterwards we found ourselves lying on our backs in the cave with a yawning opening in the snow-drift, the while our massive friend measured his diminished circumference with a loop of rope. The others then came in and made themselves at home on ropes, ice-axes, and other people's cameras. We were a party of ten, large enough to be a merry one. Our surroundings were weird and savage, unlike the British notions for a Christmas Day, but I remember that we behaved like civilized people in perhaps one respect. We discussed the year's literature.

Rock-Climbing in the English Lake District Owen Glynne Jones, E J Morten, Didsbury, 1973

Owen Glynne Jones (1867–1899) was a pioneer rock-climber and mountaineer; this book is one of the sport's classics.

Left: Scafell Crag

JAMES FOLLETT

A Cage of Eagles

As they motored deeper into the mountains and away from the coast, Kruger noticed that the British enthusiasm for removing signposts appeared to have waned: the little town of Newby Bridge, with its neat houses and shops built of blue slate from the nearby quarries at Coniston, was clearly marked, and so was the bridge across the River Leven that the town was named after.

It was as they were crossing the river that Kruger caught his first glimpse of an English lake.

'Windermere,' said Fleming in answer to Kruger's question. 'Over ten miles long and the largest lake in the Lake District. The smaller ones are called tarns.'

The scenery changed dramatically fifteen minutes later when the winding country lane Fleming was following plunged into the deep valley of Grizedale Forest. The pleasant views across broad fields gave way to thickly wooded sombre hills which were completely hidden by countless acres of spruce and Douglas fir. The pines stood tall and silent in their regimented rows, as if well aware that they were out of character with the surrounding countryside. So closely planted were they that there was no natural light to sustain ground cover, the straight trunks grew out of bare soil that had been poisoned by generations of pine needles. There was little insect life and therefore the birdsong was conspicuous by its absence.

Fleming pulled up outside a magnificent pair of wrought iron gates set into a high slate wall. The gates' piers were crowned with large decorative stone balls. A soldier emerged from a wooden guardhouse and carefully examined the documents that Fleming showed him. Satisfied, the soldier nodded to a second guard, who grudgingly unlocked the gates and waved the Bentley through.

A Cage of Eagles, James Follett, Routledge, 1989

A thriller which takes place in 1941 at the prisoner of war camp of German officers at Grizedale Hall. The camp did actually exist. The novel features Ian Fleming, who was a naval intelligence officer during World War II, a role which would later inspire the James Bond books.

Above: Grizedale Hall gates

MICHAEL WOOD

The Fell Walker

It was a perfect day for Tessa Coleman. Early morning rain had left small clouds hanging low above the lakes and in the valleys, floating about like islands of smoke. Above 2,000 ft, mist screened the fells, but she knew from experience, and a quick listen to the local weather forecast, that there was a chance of the sun breaking through by lunchtime.

This was her kind of weather. The kind that brings mood and drama, making a masterpiece of an already transcendent landscape. She liked to capture that magic moment when the sun breaks through the mist and lights up a mountain top or sends a shaft of light down to a cloud-filled valley or, best of all, to a precipitous crag face.

Her watercolour paintings were full of swirling mists, dramatic clouds, and shafts of

sunlight highlighting the main subject, usually a high crag face. Not for her the gentle, pastoral views of the Lake District that dominated the towns' gift shops, pandering to the tourists who viewed it all from the windows of their cars.

She was a climber as well as an artist. Her paintings were born of her love of the high places where she set her small, athletic frame against the might of the mountain. There was nothing more fulfilling than climbing a difficult crag, then capturing it forever on paper. Both were experienced through your fingertips. A lack of concentration, determination or skill, and both ended in disaster, albeit with greatly differing consequences. She enjoyed the challenge; she loved taking risks; it made her alive.

The Fell Walker, Michael Wood
Pen Press Publishers, Brighton, 2006

Michael Wood's debut novel: a thriller set solidly in the Lake District and also Manila and the Scottish highlands.

Above: Harrison Stickle and Crinkle Crags from Seat Sandal

SAMANTHA PRIESTLEY

Despite Losing it on Finkle Street

Will was just waking up as they approached the tiny swell of Buttermere village, and the sight of the church sent his memory bank even further into overload.

They parked. Will's body was numb as he got out of the van beside walkers and tourists, while Rachel simply felt the relief of being able to stretch her legs. They went straight down to the lake.

The fields at either side of the track that led down there were swaying with yellow grass. And the hills behind the lake were like great, docile bumps in the earth. Everything seemed so calm, so serene. They could see the ridge between the two hills beyond the lake where hikers could pass from this pool of water to another without the heave of the roads.

At the lake the trees dipped their branches over in a tattered arc, almost touching the cool water, water that seemed to be lapping like a gentle sea onto the pebbly bay, instead of frozen still like before. It seemed to whisper, as the sun shining upon it followed the ripples on the surface. He could watch it for hours and try to follow the pattern, its shape, the rhythmic shimmy.

They sat down on the ground together at the side of the lake and Rachel asked Will if he wanted to be left alone at all to think about Theresa, maybe say a few words, maybe pray. He didn't. He said, with just a hint of embarrassment, that he never wanted to be left alone again.

The water was so shallow. The edges of it were nothing but a trickle. Is it true that you can drown in such shallow water?

He picked at pebbles and stones, and took some out of the cool water as if panning for gold. One bright white stone was left in his palm. Like an old perfectly preserved fossil. A pure bone. A secret.

Despite Losing it on Finkle Street
Samantha Priestley
Pioneer Readers, 2007

A story of shifting perceptions of family relationships told with poetic imagery of its glorious Lakeland setting.

Above: Buttermere

Above: Crosbythwaite Bridge on the Ulpha to Eskdale road

Mike Carden and his son spent nine days cycling around the Lake District, taking in every lake, tackling every mountain pass and visiting a lot of the pubs and tea shops too.

MIKE CARDEN

A Lake District Grand Tour

We got back on our bikes and pedalled to the turn that would take us out of Dunnerdale.

It was massively steep.

It felt very unfair.

The road bent and twisted up through woods.

Steep, steep.

Legs. Aargghh.

Richard did his usual trick.

I did mine.

He was waiting for me at the top by a sign that showed we had just come up a 25% gradient.

'25%!' I said. 'Blooming 'eck. No wonder that was hard.'

Down a lane, a white farmhouse stood out against a backdrop of green fells close to, and darker, higher peaks beyond, the one a conical volcano shape. There was also what looked distinctly like a stone circle, or rather, a double circle of stones. One larger stone was up on end, the others prone, like sheep on one of their lazier days.

There are about fifty stone circles in Cumbria – fifty that are recorded anyway and have not been destroyed during various purges of the pagan over the centuries. Fifty is a lot of stone circles for a relatively small area, but then, I suppose, Cumbria has a lot of stone to play with.

Clouds were beginning to gather over the tops, some of them distinctly darker than others. We had missed the forecast rain, so far at least. If it started now, well, we'd get wet, but we were nearly there.

The narrow road ran through dry stone walls to reach a plateau, with red-marked, black-faced sheep in ridiculously emerald fields on one side, and a boggy, gently sloping hill on the other. At a kink in the road, a beautiful arched stone bridge took us over a little beck with Herdwicks chewing the grass nearby. The road rose again, not steeply at all; this was gorgeous cycling now, with high hills in the distance almost every way we looked.

A Lake District Grand Tour, Pedalling through Lakeland: the challenge, the history, the wildlife, the scones
Mike Carden, Bike Ride Books, Bridport, 2013

PETE MAY

Man about Tarn

Walking up from Pooley Bridge it's fascinating to reflect that I'm following the path of Roman Legions who used to trek between forts at Ambleside and Penrith, covering 20 miles every five hours across the mountains, before relaxing in a hot bath full of Roman Radox.

First there's an intriguing detour to the Cockpit, a Neolithic standing stone circle – or did the Romans put them there just to keep *Time Team* busy? Then a yomp across boggy grass and sphagnum moss up to the mountain plateau. As my boots become saturated, even in July, I reflect just how hard it must have been for Italian geezers in sandals longing for olive oil and sundried tomatoes. You can still see where the Romans used the gradient of the rock to facilitate their progress. As my boots sink in the peaty mulch once more, the attraction of a decent surface and camber becomes obvious.

Also in evidence is the Romans' unsentimental approach to walking. The path skirts all the stunning view over Ullswater and sticks resolutely to the drab upland commons – although the view are much more spectacular near the High Street summit. It was a military road all about safe passage and concealment from hostile Scots, Cumbrians and Geordies. No time for Wainwright guidebooks here.

After two and a half hours I make it across eroded peat and water pools to the summit of Loadpot Hill. It's really just a hill in the middle of a wide grassy plateau, but the views across to the Helvellyn range are good.

The path continues for another four miles to the summit of High Street where the locals held horse races 200 years ago. But for me it's time to return for a pint at Pooley Bridge. Maybe it's best the Romans left these shores some 1,600 years ago. If they were still in control the M6 would probably head straight across Lakeland's most loved peaks.

Man about Tarn: How a Londoner Learned to Love the Lake District, Pete May, independently published, 2018

Pete May is a sports author and journalist who, throughout his life, has escaped north whenever possible to enjoy walking the Lakeland fells.

Right: Roman road over High Street

IAN HALL

Thorneythwaite Farm

Truth to tell, the wad mine had been in trouble for nigh on twenty years. Even in the legendary Billy Dixon's time – and he was a wad miner and gaffer of huge ability – the wad had been drying up, and he'd ended up being required by the company to sack the eight men still searching for new sops. A new board of directors poured money into the dying company in a desperate attempt to find a big deposit, but it was a waste of time, money and muscle, and on 16th June 1891 the company and the mines were officially wound up. I was fifteen at the time and I can remember a real feeling of mourning in the valley at the news. Not that we're a soft lot – anything but – but wad had somehow got under our skin. There was a pride in being the only place in the world where such quality graphite existed, as if Borrowdale had been marked out by God as a special place.

Then there were the stories, the legends; of Moses Rigg and his trod and whisky still; of Black Sal from Rosthwaite who scratted a few bits of wad from the spoil heaps to hide away in the walls of her cottage, only to have it all washed away in a flood. Black Sal was used to scare the kids to sleep, with tales of her end – torn apart by wolf-hounds at the foot of Thorneythwaite Fell. She gave me some bad dreams, I can tell you, living right beside where she died. In a quiet way we loved the notoriety wad brought, the air of mystery, the tourists who came to gape and to gasp at the awesome holes the miners disappeared into each morning.

And then of course there were the various pencil factories in Keswick, an ongoing reminder of a once great industry. The tourists still came to visit them and to buy fine cedarwood pencils, but now the lead in them came from Korea, Ceylon and Mexico.

Thorneythwaite Farm, Borrowdale: The 1,000 year story of a Lakeland farm and its valley, Ian Hall Orchard House Books, Applethwaite, 2017

An intriguing mix of the well-documented history of this fell farm and its dale combined with the author imagining the lives of the people mentioned in that history and his own recollections of living and working on the farm as a teenager with his parents.

Left: Spoil heaps, Seathwaite

ALFRED WAINWRIGHT

Fellwanderer

I was twenty-three before I could afford a holiday away from home. I had heard of the wonders of the Lake District. It was only sixty miles away, but, until now, another world, distant, unattainable. I went there with a cousin for a week's walking. Well, I was utterly enslaved by all I saw. I gazed in disbelief at the loveliness around me. I had never thought there could be beauty like this, never imagined such enchantment, never knew there could be so much colour and charm in a landscape. Here were no huge factories, but mountains; no stagnant canals, but sparkling fastnesses of the hills. Here was quietness, not noise. Here were flowers, not weeds. And we were free to wander: that was the special joy of it. We could stand and admire the heights from the valley, or we could climb and be part of the scene. We could look at the mountains from the lakes, or we could look at the lakes from the mountains. There was a new and wonderful freedom here: it wasn't necessary to wait until the policeman had passed on his beat. And there was carefree exhilaration, and beauty that brought tears.

The people of the villages and valleys were friendly and kind, as indeed were the people of Blackburn, but here they had a tranquillity of character, a shy and quiet contentment I had not experienced before but could understand. Everything was wonderful, even the rain. That week changed my life; its haunting perfection gave me no rest afterwards. For me there could be no other place, and when in due course an opportunity offered itself the Lake District became my home. Truly my home. Not merely a place to work and eat and go to bed. A place to live. A place to be. I had no roots there, but I resolved to grow some, and they would go deep, into the very rocks.

Fellwanderer: The story behind the Guidebooks, Alfred Wainwright
Westmorland Gazette, Kendal, 1966

When A.W. first visited and fell in love with the Lakes, who could have guessed the influence this would have? The seven volumes of his unique walking guidebooks, which are reproductions of his hand-written manuscripts and drawings, have sold over two million copies and remain among the most popular guidebooks to the area. The 214 fells he describes in the Pictorial Guides are known as 'Wainwrights' and many hikers and climbers enjoy the challenge of 'bagging' all of these summits.

Right: Whiteless Pike reflected in Buttermere

SIR EDWARD BAINES

A Companion to the Lakes of Cumberland, Westmoreland, and Lancashire

Thursday was a glorious morning, and I set off for Borrowdale, having marked out the ascent of Great Gavel for that day's work, and the ascent of Langdale Pikes for the following day. When passing under Falcon Crag, about half way up the lake, one of the richest and loveliest pictures ever seen or dreamed of presented itself. The lofty and steep slope of Catbells, decked in all those hues with which October invests the hills, rich brown and lemon colour, mingled with green, and streaked here and there like a dove's neck from the effect of slate and metallic ore, was illuminated by a brilliant morning sun; and the whole hill-side was reflected from the mirror of Derwentwater without a wrinkle. The inverted image was actually brighter than the hill itself, as it received a lustre from the glassy surface on which it was painted.

As I proceeded towards Barrow-house, the richly wooded islands, with their mellow autumnal foliage, the beautiful vale of Newlands, the embrowned ridge of Swinside, the plantations of Derwent-bay and Derwent-bank, the black horn of Causey Pike, and finally the whole mass of Skiddaw with his azure peaks, were successively, and at length all together seen reflected from the surface of the lake,—the most glorious and inimitable picture I ever witnessed.

A Companion To The Lakes Of Cumberland, Westmoreland, And Lancashire
Sir Edward Baines, Simpkin & Marshall, 1834

Edward Baines (1800-1890) was a newspaper editor and a Liberal MP. He accompanied his two cousins and a maiden aunt on this tour and here combines 'the accuracy of a guide-book with the liveliness and interest of a personal narrative'. He also assures us that 'Ladies in particular will learn what enterprises they may safely attempt in the mountainous region, and where they would be exposed to danger or excessive fatigue.'

Left: Skiddaw reflected in Derwent Water

HARRIET MARTINEAU

A Year at Ambleside

What a contrast was the scene we returned to! What a noise of mirth and feeding! How the beef and bread disappeared when every bone of each goose was picked! And the pies and cakes – how they melted away out of sight! The people here keep no beer in the house at ordinary times: because of the watching of the excise when they serve refreshment to strangers, lest they, having no license, should furnish any excisable article for pay.

But now, how the beer-jugs went round! The men were thirsty with their harvest-home labours, and, they said, with shouting the tidings along the vale: so they drank heartily, not intemperately, however, for they cared more for the dance than the pleasures of the table.

While the elderly men sat in the porch, and on the benches outside the house, smoking their pipes, and comparing all the harvest-homes they had known, the lads and lasses, the fiddler and a drummer that they had by some means caught, adjourned to a loft for the dance.

'A Year at Ambleside, by Harriet Martineau' from *Harriet Martineau at Ambleside* by Barbara Todd, Bookcase, Carlisle, 2002

Harriet Martineau was a journalist, writer of fiction, social analyses, books on travel and social reform, a campaigner against slavery and for women's rights, and is often considered the first British female sociologist. After a prolonged period of ill health, she moved to the Lake District in 1845 and spent the rest of her life at Ambleside, living in a house which she designed.

Right: Millbeck Farm beneath Harrison Stickle, Great Langdale

HUNTER DAVIES

A Walk Around the Lakes

Stickle Tarn came as a sudden and beautiful surprise and I almost exclaimed in excitement. I had been turning round every few yards on the scree slopes, admiring the changing view below. It had started with a view back down Great Langdale. Then slowly as I got higher, I caught glimpses of Coniston Water.

Higher still, Coniston appeared to be suspended wholly in mid-air, as if I could stretch over and touch it. So it was a surprise, turning away from all those fine views, to find myself facing the tarn. Such calm, still water, so smooth and inviting, with behind, rising sheer out of the tarn, the tremendous rock face of Pavey Ark.

A Walk Around the Lakes, Hunter Davies
Frances Lincoln Ltd, London, 2009

Hunter Davies spent a year exploring the Lakes and the lives of the region's notable characters.

Left: Stickle Tarn and Pavey Ark

MARTIN EDWARDS

The Hanging Wood

'Ruskin said this was one of the three most beautiful scenes in Europe', he said.

'I can believe it.' She pointed towards the fells flanking the lake. 'Got your bearings? That's Cat Bells to the west, Castlerigg Fell to the east. Behind you is Derwent Isle. And the biggest island, over there in the middle of the lake, is St Herberts, where the hermit of Derwent Water lived. One summer when I was a student, a couple of friends and I rowed out there. The plan was to stay overnight in a tent.'

'I never knew you liked life under canvas.'

'Once was enough. We'd had too much to drink, and the tent collapsed an hour after we landed. Before we could put it back up again, there was a violent storm, with thunder and lightning. We were scared to death as well as soaked to the skin. These days, people camp on the island for corporate team-building events. I hope they have more joy than the three of us – we were barely speaking to each other by the time we made it back to dry land. St Herbert could keep his island hermitage, as far as I was concerned.'

The Hanging Wood, Martin Edwards
Allison & Busby Ltd, London, 2011 © Martin Edwards
Licenced by Watson, Little Ltd

The Hanging Wood *is part of the Lake District Mystery series written by Martin Edwards. In 2020 he was awarded the Crime Writers' Association Diamond Dagger, the highest honour in British crime writing.*

Right: Derwent Isle, Derwent Water

TAFFY THOMAS

The Rock Climbers

In the years leading up to 1900, two young men loved to test their skill, strength and courage together on the rock faces that grace the likes of Scafell, Skiddaw and Helvellyn. With the start of the First World War, Lord Kitchener pointed his finger and one of the pair answered the call, heading for France, Belgium and the horrors of trench warfare. His friend continued on days off to rockclimb, although it had become a lonelier and more dangerous activity, as any solo climber knows. One sunny day after a particularly tough route on Scafell Crag, he was walking down Hollow Stones when he heard a cheery whistling. Coming towards him he was delighted to see the smiling face of his soldier friend, presumably home on leave, going up to do the route he himself had just conquered. They chatted of what they might do when the war was over. Parting, they agreed to meet up later at the Wasdale Head Inn for a pint.

The soldier never showed up for that drink. A couple of days later, the climber heard that his friend had fallen at Passchendaele, at exactly the time they had met in the beautiful sunshine of a Lakeland summer. Those who share a love of the mountains are often aware of experiencing an abiding sense of spirituality in that landscape.

The Rock Climbers, Cumbrian Folk Tales, Taffy Thomas MBE, The History Press, 2012

Cumbria has a good store of legends and ghost stories: this is the account of a young rock climber's strange experience during the First World War. Taffy Thomas was appointed the first UK Storyteller Laureate in 2010.

Photo: Striding Edge, Helvellyn

A. H. GRIFFIN

The Finest Pool of All

The best place to be during the recent heat-wave has been nicely submerged in a Lake District pool – preferably with a waterfall at one end, pleasantly shadowed by an overhanging rowan and close by a bank of sweet-scented thyme. In this way, on the hottest and sultriest day – especially after long exertions on the heights – supreme contentment may be achieved for ten minutes or so, and the tired wanderer will emerge like a giant refreshed. The Lake District, in spite of all its water, is not always the best place for swimming, the lakes often being too cold, too crowded or dangerous with currents and unsuspected depths, and the tarns sometimes weed-choked or rocky, but for the occasional dip on a scorching day the opportunities are exceptional.

There are nearly 500 mountain tarns in the national park, but the pools in the becks have never been counted; there could be thousands of them. The upper Esk, the Duddon, the Derwent, the Lingcove Beck, Grains Gill, and scores of other dancing waters all have their pools, strung along their twisting courses like pearls in a necklace, and hundreds of them invite the weary traveller to jump in and forget his aches and pains. Some are only large enough to allow you to slide in off the rocks and take about two strokes, but one of the very best of them must be many yards long and at least twenty feet deep – a cool, dark canyon between glistening, vertical walls that might have been built for the job.

To reach this place, two miles away from motor coaches and litter bins, at the end of a long day is to reach something like paradise – the thunder of the falls in your ears, the spray in your eyes, the sun glinting on the rocks, the shingle shining in dark depths. There's only one thing to do – jump in and become a new man.

A Year in the Fells, A H Griffin, Robert Hale Ltd, London, 1976

A. Harry Griffin was a journalist and mountaineer who wrote a 'Country Diary' column from his Lakeland home for The Guardian *for over fifty years. He was also a friend of Alfred Wainwright.*

Right: Pool on the upper River Esk

WILLIAM WORDSWORTH

Aira Force Valley

Not a breath of air
Ruffles the bosom of this leafy glen.
From the brook's margin, wide around, the trees
Are steadfast as the rocks; the brook itself,
Old as the hills that feed it from afar,
Doth rather deepen than disturb the calm
Where all things else are still and motionless.
And yet, even now, a little breeze, perchance
Escaped from boisterous winds that rage without,
Has entered, by the sturdy oaks unfelt,
But to its gentle touch how sensitive
Is the light ash! that, pendant from the brow
Of yon dim cave, in seeming silence makes
A soft eye-music of slow-waving boughs,
Powerful almost as vocal harmony
To stay the wanderer's steps and soothe his thoughts.

Wordsworth frequently walked in the area around Aira Force ('force' is the Old Norse word for waterfall) and the falls are referenced in several of his poems. The daffodils which inspired both him and Dorothy were growing nearby, where Aira Beck flows into Ullswater.

Left: Aira Force waterfall above Ullswater

BEATRIX POTTER

The Fairy Caravan

'Ruth Twinter, do you remember the Down ram, telling us about the Cotswold flocks? How with each flock a two-three sheep go before, wearing bells? When they lift their heads from nibbling and step forward, the bells ring – ting ting ting – tong tong tong – tinkle tinkle tinkle! Why has Mistress Heelis never given us bells? She will do anything for us sheep?'

'I know not,' answered Ruth Twinter.

'I can tell you from the wisdom of age,' said the old Blue Ewe (sixteen years gone by since first she nibbled the clover); 'I can tell you. It is because we Herdwicks range singly and free upon the mountain side. We are not like the silly Southron sheep, that flock after a bell-wether. The Cotswold sheep feed on smooth sloping pastures near their shepherd.'

Said the peet ewe, Blindey, 'Our northern winds would blow away the sheep bells' feeble tinkle. From the low grounds to us comes a sound that carries further – Old John calling with a voice like a bell; calling his sheep to hay across the frozen snow in winter.'

Up spoke a dark Lonscale ewe – 'Each to their own! The green fields of the south for them; the high fell tops for us who use to wander, and find our way alone, through mist and track-less waste. We need no human guide to set us on our way.'

'No guide, nor star, nor compass, to set us a bee-line to Eskdale!'

The Fairy Caravan, Beatrix Potter, Frederick Warne & Co., London and New York, 1952

Beatrix Potter wrote this story of a travelling circus of small animals for American friends who loved the Lake District. 'Mistress Heelis' as mentioned here was, of course, her married name.

Right: Looking towards Ill Bell and Thornthwaite Crag from Orrest Head

ROBERT SOUTHEY

The Cataract of Lodore

From its sources which well
In the Tarn on the fell;
From its fountains
In the mountains,
Its rills and its gills;
Through moss and through brake,
It runs and it creeps
For a while, till it sleeps
In its own little Lake.
And thence at departing,
Awakening and starting,
It runs through the reeds
And away it proceeds,
Through meadow and glade,
In sun and in shade,
And through the wood-shelter,
Among crags in its flurry,
Helter-skelter,
Hurry-scurry.
Here it comes sparkling,
And there it comes darkling –
Now smoking and frothing
Its tumult and wrath in,
Till in this rapid race
On which it is bent,
It reaches the place
Of its steep descent.

The Cataract strong
Then plunges along,
Striking and raging
As if a war waging
Its caverns and rocks among:
Rising and leaping,
Sinking and creeping,
Showering and springing,
Flying and flinging,
Writhing and ringing,
Eddying and whisking,
Spouting and frisking,
Turning and twisting,
Around and around
With endless rebound!
Smiting and fighting,
A sight to delight in;
Confounding, astounding,
Dizzying and deafening the ear with its sound.

This is from one of Robert Southey's most popular poems which he wrote in 1820 for his children.

Right: Lodore Falls in winter

CHARLES DICKENS

The Lazy Tour of Two Idle Apprentices

Up and up and up again, till a ridge is reached and the outer edge of the mist on the summit of Carrock is darkly and drizzingly near. Is this the top? No, nothing like the top. It is an aggravating peculiarity of all mountains, that, although they have only one top when they are seen (as they ought always to be seen) from below, they turn out to have a perfect eruption of false tops whenever the traveller is sufficiently ill-advised to go out of his way for the purpose of ascending them. Carrock is but a trumpery little mountain of fifteen hundred feet, and it presumes to have false tops, and even precipices, as if it were Mont Blanc.

No matter; Goodchild enjoys it, and will go on; and Idle, who is afraid of being left behind by himself, must follow. On entering the edge of the mist, the landlord stops, and says he hopes that it will not get any thicker. It is twenty years since he last ascended Carrock, and it is barely possible, if the mist increases, that the party may be lost on the mountain.

Goodchild hears this dreadful intimation, and is not in the least impressed by it. He marches for the top that is never to be found, as if he was the Wandering Jew, bound to go on for ever, in defiance of everything. The

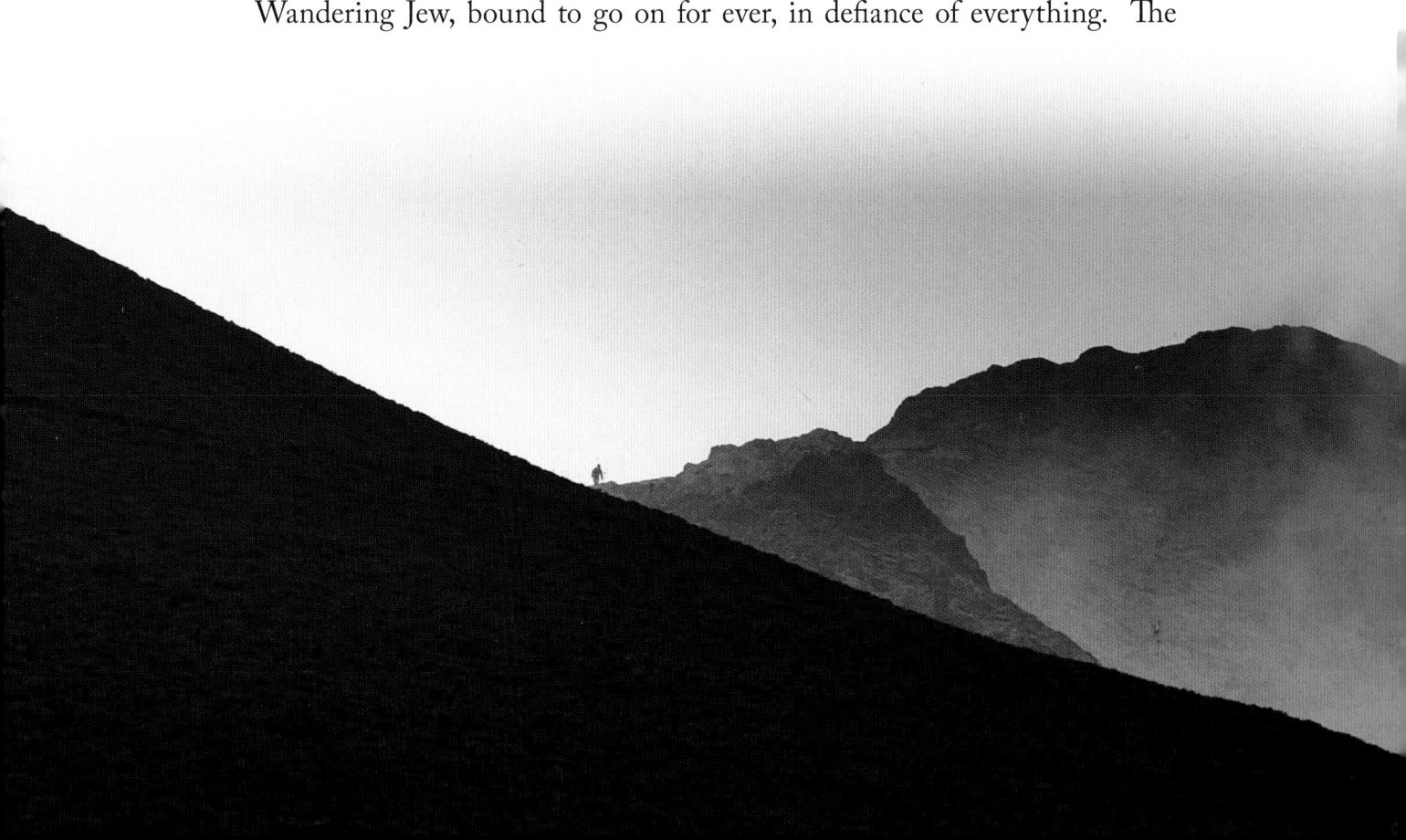

landlord faithfully accompanies him. The two, to the dim eye of Idle, far below, look in the exaggerative mist, like a pair of friendly giants, mounting the steps of some invisible castle together. Up and up, and then down a little, and then up, and then along a strip of level ground, and then up again.

The wind, a wind unknown in the happy valley, blows keen and strong; the rain-mist gets impenetrable; a dreary little cairn of stones appears. The landlord adds one to the heap, first walking all round the cairn as if he were about to perform an incantation, then dropping the stone on to the top of the heap with the gesture of a magician adding an ingredient to a cauldron in full bubble. Goodchild sits down by the cairn as if it was his study-table at home; Idle, drenched and panting, stands up with his back to the wind, ascertains distinctly that this is the top at last, looks round with all the little curiosity that is left in him, and gets, in return, a magnificent view of – Nothing!

The Lazy Tour of Two Idle Apprentices, Charles Dickens, Chapman & Hall, London, 1905

In September 1857 Charles Dickens and his friend Wilkie Collins went on a walking tour of Cumberland and wrote of their adventures for the periodical Household Words.

Photo: Hall's Fell Ridge, Blencathra

ALFRED WAINWRIGHT

Fellwanderer

And afterwards, a last long resting place by the side of Innominate Tarn, on Haystacks, where the water gently laps the gravelly shore and the heather blooms and Pillar and Gable keep unfailing watch. A quiet place, a lonely place. I shall go to it, for the last time, and be carried: someone who knew me in life will take me and empty me out of a little box and leave me there alone.

And if you, dear reader, should get a bit of grit in your boot as you are crossing Haystacks in the years to come, please treat it with respect. It might be me.

Fellwanderer: The story behind the Guidebooks, Alfred Wainwright
Westmorland Gazette, Kendal, 1966

For someone who described himself as antisocial, but who became a reluctant TV personality, the solitude of Innominate Tarn in his beloved Lakes is a perfect final resting place for A.W.

Left: Innominate Tarn, Haystacks.
Pillar in the distance

PHOTOGRAPHER'S NOTES

I used a Canon 5d Mark III for the majority of the images, though some earlier ones from my collections of Lake District images were taken on a Canon 5D and even, very early on, a Canon 300D. My main lens used was a Canon 70-200mm f2.8 L IS USM lens plus a combination of other Canon prime wide angle and zoom lenses.

Half-title page: This shows the scale of Whiteless Pike above Crummock Water. The cottage below is completely dwarfed.

Title page: The far end of Crummock Water on a perfect summer day.

p.8 Although the poem refers to daffodils seen by Wordsworth at Ullswater, the greatest and most photogenic (and most moving) "host" of wild daffodils I found was here at Dora's Field at Rydal. The daffodils were planted by William Wordsworth in memory of his daughter Dorothy (Dora) who died at Rydal of TB.

p.11 This image was taken in the early morning at the start of an ascent up Skiddaw. The mountains stretched away into the distance as far as Glaramara and Great End at the far end of Borrowdale.

p.12 I love the fact that in this image there is a perfect mirrored reflection of Place Fell on Ullswater but that the stones of the bottom of the lake can also be seen through the clear water.

p.15 I took this image before breakfast one frosty morning when I was staying at Elterwater. There wasn't another person about.

p.17 I had just finished a strenuous climb to Sprinkling Tarn in the hope of getting an image of a rainbow across the Gables, but once up at 2000 feet the clouds came down and it poured with rain. I had given up hope of an image that day when, back at Wasdale Head, the clouds lifted and shafts of sunlight illuminated the summit and slopes of the magnificent Great Gable.

p.18 I found this glorious green bower next to the Bowder Stone track on the slopes above Borrowdale.

p.21 Langstrath is such an empty, long, vast valley, with Esk Pike and Great End at its head, that it is indeed an elemental place.

p.22 Glorious colours on the flanks of Skiddaw on a perfect autumn day.

p.24 This unusual view of Keswick, with the massive bulk of Skiddaw as a backdrop, was taken from Hope Park gardens.

p.28 I was lucky enough to capture these two small sailing boats next to Peel Island on Coniston Water.

p.30 I had tried several times to capture an image of Pillar Rock in Ennerdale, but with very little snow during the winter I was working on this book, this was the only chance I had to get a suitably snowy image.

p.32 Very often when the water is low Haweswater has ugly bare shores as it is a reservoir, but on this occasion, after weeks of rain, it was looking particularly beautiful. I hope this image does justice to the valley and villages of Mardale lying beneath the water.

p.34 I don't think I have ever seen Kentmere looking as stunning as on this autumn morning.

p.36 This image seems to me capture the drama of the Borrowdale valley as described in the extract.

p.38 I swam in this pool after I took the photograph. It was heaven.

p.42 I would love to have to captured an image of a stag gazing over a wall behind Dove Cottage as described in the extract but I fear that I would still be sat amongst the bracken, waiting! I hope this image captures the spirit of the piece instead.

p.46 I got up at 3am on a perfect summer morning to photograph Buttermere and then walked down Crummock Water below Mellbreak and I too swam from this pebbly beach at Low Ling Crag.

p.55 I would have liked to have managed to get a shot of the moon reflected in Rydal Water but the opportunity just never presented itself as every time there was a full moon it was either cloudy or I was somewhere else!

p.50 Castlerigg Stone Circle is rarely seen without visitors around but on this day I got up very early and was lucky enough to see the stones dramatically lit by the rising sun.

p.54 I love this view of Causey Pike and the Derwent Fells as seen from Castlerigg Stone Circle.

p.56 The Three Shire Stone doesn't feature in this image as at the time it had been absent for several years for repair.

p.60 I wanted to capture both Dollywaggon Pike, St Sunday Crag and Fairfield in this shot.

p.62 This sunset over the black bulk of Skiddaw seemed to capture the joy and exuberance of Southey and friends.

p.67 This shot was taken on a descent from Helvellyn on a very cold winter day. Earlier in the day Ullswater had been hidden by fog but as I descended back to Glenridding the fog rose enough to reveal this lovely scene.

p.70 Nethermost Pike catching the first rays of the sun on a very early morning start as I set off up to the Hole in the Wall path towards Helvellyn.

p.72 Looking towards Derwent Water and the Newlands Valley late in the day from near Millbeck, below Skiddaw.

p.74 The road over Wrynose Pass from the heart of the Lakes to reach Cockley Beck was closed by snow so I had a very long drive up the Duddon Valley to get this shot. Amazingly, even though there were prominent signs saying the road was closed several cars came over Hard Knott Pass and carried on towards Wrynose!

PHOTOGRAPHER'S NOTES

p.76 This is Bridge House, where John Richardson lived. The shot is taken from the narrow track up to St John's in the Vale church.

p.81 Haverthwaite Heights seems to be a secret part of the Lakes. On the walk through the woods to find the charcoal burner huts I didn't meet another person.

p.82 There is a classic view of Shepherd's Crag in Borrowdale which shows Derwent Water behind, but I liked this image of the crag towering above the white cottage below and the tiny figures of the climbers demonstrate the scale of the rock.

p.86 This image does seem to capture a sense of impregnability and a secret valley as it looks up beyond Rannerdale Knotts.

p.89 Trying to get to Wasdale Head and up the Scafells in deep snow would have been wonderful to do, but there was very little snow in the winter that I was working on this book, and in all honesty I don't think I would have attempted what Owen Glynne Jones and his party did in any case, but I think this image represents the drama that is Scafell.

p.91 I envisaged an atmospheric shot looking through the closed gates of Grizedale Hall. However the gates are now permanently open and behind them is a large parking area, so I had to content myself with a view in the opposite direction.

p.92 On the slopes of Seat Sandal on the way up to Grisedale Tarn I looked back to see this wonderful panorama of snow covered fells, with Pavey Ark on the right, going round to Harrison Stickle and Crinkle Crags.

p.95 This was taken at about 7am, just before I jumped into Buttermere for a swim.

p.96 It is a very steep, quiet and tiny road out of Dunnerdale to reach this beautiful little bridge over Crosby Gill.

p.98 The Roman Road (height 2,500ft) on High Street.

p.100 The spoil heaps might seem incongruous in the beautiful Lakes, but here above Seathwaite they seem to fit into the landscape.

p.102 Buttermere was so still on the morning that I took this image and the fells were so perfectly mirrored in the water that it was hard to decide where the land ended and the lake began.

p.104 It was yet another early start to grab this image. I had been waiting weeks for a windless morning when I knew that I could get great reflections in Derwent Water.

p.106 The extract refers to drinking at Millbeck Farm. This farm, in its setting below the Langdale Pikes, is I think now a B&B, so the trend of hospitality here continues.

p.108 I had set out on a very calm day to capture the still waters of Stickle Tarn, but by the time I arrived up there at 1500 feet, there was a bit of a breeze blowing across the tarn. It was very warm though, and several people were swimming. I promised myself a swim after completing Pavey Ark but by the time I got back down it had turned too cold. I did paddle though.

p.110 I felt the rather grey sky and stormy feel of this image matched the description of the disastrous camping trip in the extract. The island pictured is Derwent Isle rather than St Herbert's Isle, but the extract is also talking about Derwent Isle and Cat Bells.

p.112 At first I was looking for a suitable image around Scafell crag but then I managed to capture this image of two climbers on Striding Edge. The still and upright pose of the man on the right, with the circle of light behind him, and the fact that his clothes could almost be a First World War uniform, gave me quite a spooky feeling.

p.114 This pool, on the upper reaches of the River Esk, near Lingcove Bridge, is one of the best in the Lake District for wild swimming.

p.116 I made several visits to Aira Force until I finally got the image I was happy with. I wanted to make sure I included the pretty stone bridge above as well as the beautiful clear pool at the foot of the waterfall.

p.118 This image is of the mountains above Trout Beck valley. Beatrix Potter used Troutbeck Park Farm in the valley as the setting for her Fairy caravan stories and wrote some of the stories from a study she had at the farm.

p.121 I visited Lodore Falls after several days of heavy rain and you could hear the falls from some distance away.

p.122 This was taken after I had completed the climb of Blencathra via Halls Fell Ridge, in misty conditions which I found quite scary. I admit at one particular crux on the ridge I did shed a few tears of fear! Whilst it is not Dickens' Carrock, it does seem to fit his description so perfectly.

p.124 It felt quite poignant standing there beside Innominate Tarn, knowing that this was Wainwright's final resting place, and that my work taking photographs for this book was finished.

I would like to dedicate my photography to all the wonderful writers who inspired the images in the book and to my husband Bob for supporting me on my many walks in the Lakes whilst working on *A String of Pearls*.
Helen Shaw 2021

INDEX